CRISTINA IGLESIAS

Cristina Iglesias

edited by
CARMEN GIMENEZ

GUGGENHEIM MUSEUM

CRISTINA IGLESIAS
curated by Carmen Giménez

Solomon R. Guggenheim Museum, New York
June 18 – September 7, 1997

The Renaissance Society, Chicago
November 1997 – January 1998

Museo Nacional Centro de Arte Reina Sofía, Madrid
Palacio de Velázquez
February 5 – April 20, 1998

Guggenheim Museum Bilbao
Summer 1998

This exhibition and accompanying catalogue have been made possible by generous grants from
the Ministerio de Educación y Cultura, Dirección General de Bellas Artes y Bienes Culturales
(Ministry of Education and Culture of Spain, General Department of Fine Arts) and Carolina Herrera.

CATALOGUE

Concept by Cristina Iglesias
Design by Leopold en Zonen, Ghent, Belgium

Production by Ediciones El Viso, Santiago Saavedra, Madrid
Printed in Spain

ISBN 0-8109-6904-1 (hardcover)
ISBN 0-89207-189-3 (softcover)

Guggenheim Museum Publications
1071 Fifth Avenue
New York, New York 10128

Hardcover edition distributed by
Harry N. Abrams, Inc.
100 Fifth Avenue
New York, New York 10011

PHOTO CREDITS

Luis Asín (Madrid), Javier Azurmendi (Madrid),
Kristien Daem (Ghent), Dorothee Fischer (Düsseldorf),
Claire Garoutte (Seattle), Antxon Hernández (San Sebastián),
Atillio Maranzano (Rome), Dimitris Tamviskos (Athens),
Werner Zellien (Berlin), and Cristina Iglesias

PREFACE

THOMAS KRENS

Cristina Iglesias's work exemplifies the great strength and imagination of Spanish art today. One of an emerging generation of artists from this country, Iglesias creates work that is both innovative and connected to the past. Her archetypal forms and lyrical structures redefine our perceptions of architectural and natural spaces; her intricate surfaces and tactile materials are rooted in the rich aesthetic heritage of her native region.

With this exhibition, the Guggenheim Museum inaugurates a series of presentations of contemporary Basque and Spanish art; the series will continue following the opening of the Guggenheim Museum Bilbao later this year. The enthusiastic and generous support of the Ministry of Education and Culture of Spain has been critical to the successful realization of this exhibition. I extend my great appreciation to Esperanza Aguirre Gil de Biedma, Minister of Education and Culture; Miguel

PREFACE

Angel Cortés Martín, Secretary of State for Culture; Benigno Pendás, General Director of Fine Arts; and José Guirao Cabrera, Director of the Museo Nacional Centro de Arte Reina Sofía, Madrid.

For their generous patronage, I extend my deep gratitude to Carolina Herrera Perfumes, New York, and Antonio Puig Perfumes, Barcelona. Both companies have a long history of support for the arts in the United States and Spain.

To the artist herself, I extend my sincere gratitude for her dedication to the project. I am grateful also to Carmen Giménez, Curator of Twentieth-Century Art, for bringing this exhibition and catalogue to fruition. We are privileged to benefit from her vision and the results of her close collaboration with the artist.

Finally, a special note of gratitude is due to the participating venues and the lenders to this exhibition. Their cooperation and goodwill have made this presentation of Iglesias's work a successful undertaking.

ACKNOWLEDGMENTS

CARMEN GIMENEZ

While I have known Cristina Iglesias for many years and have enjoyed seeing her work in numerous exhibitions throughout Europe, it is a particular pleasure to have the opportunity to work with her on her American museum debut and to see new audiences introduced to her oeuvre.

Foremost, I wish to express my deepest gratitude to the artist. Her constant enthusiasm and limitless energy have made this exhibition possible. It has been a privilege to collaborate with her.

I am also thankful to have benefited from the involvement of Suzanne Ghez, Director of the Renaissance Society of the University of Chicago, and José Guirao Cabrera, Director of the Museo Nacional Centro de Arte Reina Sofía, Madrid, who expressed interest in and supported this project from the outset. I am pleased that this exhibition will travel to these institutions as well as to the Guggenheim Museum Bilbao. I thank Juan Ignacio

Vidarte, General Director of the Guggenheim Museum Bilbao, and his staff for their enthusiastic participation.

My heartfelt appreciation goes to all those who have offered their time and expertise to this project. In particular, I wish to thank Bart Cassiman and Richard Gluckman. I am very grateful to those who generously agreed to lend works: Guy Cambier, Dirk Buneel, and Michael Mast of BACOB Bank, Brussels; Jean Bernier of Jean Bernier Gallery, Athens; Dorothee Fischer of Galerie Konrad Fischer, Düsseldorf; and Donald Young of Donald Young Gallery, Seattle, who also provided invaluable counsel during the planning of this exhibition.

For their thoughtful catalogue essays, which shed light on the many aspects of Iglesias's work, my gratitude is extended to Nancy Princenthal, Adrian Searle, and Barbara Maria Stafford.

From conception to execution, exhibitions are a genuine team effort. Between loan forms, invitations, publications, public relations, transportation, and installation, there are many individuals to acknowledge. At the Guggenheim Museum, my deepest thanks go to Thomas Krens, Director; Lisa Dennison, Deputy Director and Chief Curator; and Judith Cox, Deputy Director and General Counsel, for their constant support of this project. I also thank Rosemarie Garipoli, Deputy Director for External Affairs; George McNeely, Director of Corporate and Foundation Giving; Stacy Bolton, Development Coordinator; Nicole Hepburn, Exhibition Administration Coordinator; Ruth Taylor, Director of Budgeting and Planning; and Wesley Jessup, Senior Financial Analyst, who have coordinated the financial aspects of this exhibition and its tour.

The role played by Tracey Bashkoff, Curatorial Assistant and Project Manager, has been crucial to the realization of both the exhibition and catalogue. To Guillermo Ovalle, Assistant Registrar, I express my thanks for expertly organizing the logistics of the transportation and insurance of the works in the exhibition. I am grateful to Eleanora Nagy, Assistant Conservator for Sculpture, for her insights and help with the care of the works.

ACKNOWLEDGMENTS

Barry Hylton, Exhibition Technician, provided thoughtful advance preparation and oversaw the complex installation. My thanks are due to all who participated in the many aspects of the installation, including Scott Wixon, Manager of Art Services and Preparations; Peter Read, Production Services Manager/Exhibition Design Coordinator; Rich Gombar, Museum Technician; Jocelyn Groom, Exhibition Design Coordinator; Mary Ann Hoag, Lighting Technician; James Cullinane, Exhibition Technician; and Walter Christie, Maintenance Technician. In addition, interns Jan D'Amore and Simon Murphy gave enthusiastically of their time during the planning stages of the exhibition.

I am indebted to Anthony Calnek, Director of Publications, for helping to bring this book to fruition, as well as to Jennifer Knox White, Associate Editor, Carol Fitzgerald, Assistant Editor, and Domenick Ammirati, Curatorial Assistant. Filiep Tacq designed the catalogue with great sensitivity and vision. I thank Santiago Saavedra and Lola Gómez de Aranda of El Viso for their careful attention to many aspects of this publication.

In Spain, my gratitude goes to Daniela Tilkin, Exhibition Coordinator, for her many contributions to the organization of the exhibition and catalogue, as well as to Iglesias's assistants Rubén Polanco, Jesús Tejero, Pepe Albacete, Guillermo Ponce, Mimi Muñoz, and, especially, Julián López, for his invaluable help during the production and installation of pieces in the exhibition.

At the Renaissance Society, my thanks are extended foremost to Hamza Walker, Director of Education; Lori Bartman, Director of Development; Patricia Scott, Bookkeeper/Office Manager; Scott Short, Preparator/Registrar; and Lisa Meyerowitz, Etal Dori, and Mark Clarson, work-study assistants. At the Museo Nacional Centro de Arte Reina Sofía, I express my special gratitude to Alicia Chillida, Coordinator, Palacio de Velázquez, for her dedication to this project.

To all of those contributing to this exhibition and publication, I wish to convey my sincere gratitude.

CONTENTS

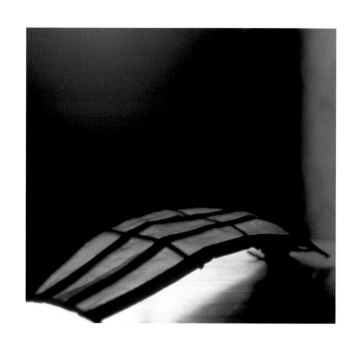

INTRODUCTION

CARMEN GIMENEZ

This presentation will be a discovery for many and a confirmation for others. Cristina Iglesias has had a brilliant career in Europe (her work having been shown at the most prestigious contemporary art exhibitions and venues, including the Venice *Biennale*, Kunsthalle Bern, and Stedelijk Van Abbe Museum, Eindhoven), but her art is known by comparatively few people in the United States, with the narrow exception of the keenest followers of current art trends. The first exhibition of the artist's work at an American museum, *Cristina Iglesias* will appear in both New York and Chicago before traveling to Madrid and Bilbao.

Iglesias belongs to a generation of artists who became known in the 1980s; committed to the poetic and symbolic aspects of both space and image, their art was deeply rooted in the most radical contemporary thought.

Yet Iglesias's work also has its own personal language, which is characterized by a complexity that stems from the creation of ambiguous spaces that open themselves to the viewer while folding into themselves. Extraordinary confrontations emerge from juxtapositions of the transparency of glass, the opacity of cement and iron, and the tactile qualities of resin, alabaster, and wood.

Iglesias's sculptures assume a specific relationship to the environments in which they are seen, and this intersection of the symbolic with formal precision called for a nonretrospective approach to this exhibition. Instead, the artist has installed works — some of which have been created specifically for this presentation — that relate to the spaces they inhabit. At the Solomon R. Guggenheim Museum, the opening venue of the exhibition tour, the installation occupies two of the museum's new tower galleries, the terrace that opens off one of those galleries, and a section of the ramp in the original Frank Lloyd Wright building.

In this latter site, an engaging and enriching dialogue is established between Iglesias's work and the surrounding architecture. One of the most significant spaces in the history of architecture, with its vast central void crowned by a broad, circular skylight, this interior reveals such a close link between form and structure that the two can scarcely be distinguished from each other.

This convergence is also present in Iglesias's sculpture. Like Wright's architecture, it takes its inspiration from the precepts of organic growth, which are applied to its structure. Its essentially organic nature creates a spatial unity, a presence that entices the spectator to explore the work's poetic or sensual intuition.

It is this very thirst for total integration between the work and the place where it is shown that has led the artist to conceive this publication, which accompanies the exhibition. Texts by Nancy Princenthal, Adrian Searle, and Barbara Maria Stafford provide interpretations — each from its own distinct viewpoint — that enrich our approach to and understanding of a body of work so deserving of our attention.

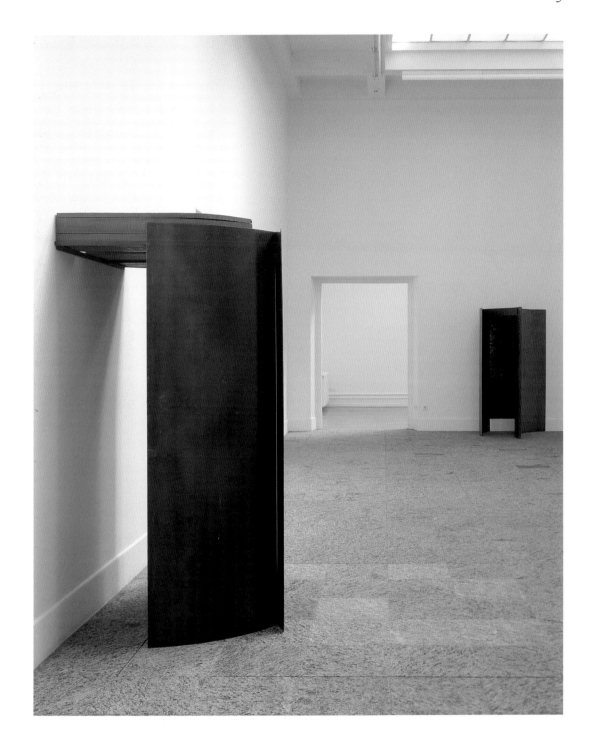

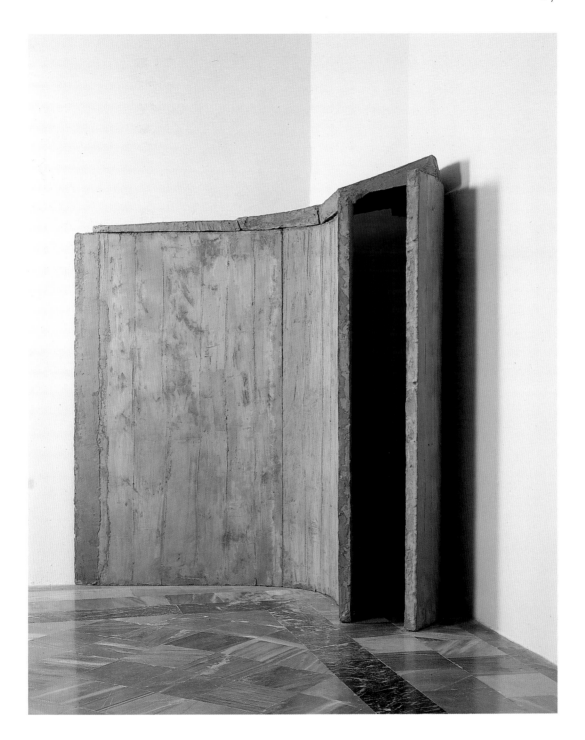

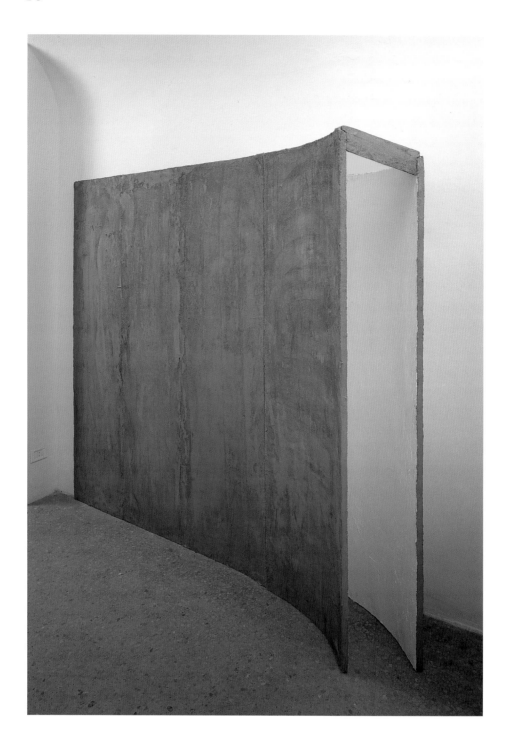

SCREEN MEMORIES

NANCY PRINCENTHAL

"As they do not owe their existence to their own contents, but to an associative relation of their contents to another repressed thought, they deserve the title of 'concealing memories.'"[1] So wrote Freud of remembered experiences that are too weak, emotionally, to survive without covert psychic support. Elsewhere, Freud chose the less unyielding term "screen memories"[2] to suggest that the opacity of these recollections was imperfect, permitting fragments of antecedent experience to show through; the term is also more sympathetic, allowing the possibility that these memories had intrinsic analytical appeal. Indeed, Freud grew to regard psychoanalysis as, in Jacqueline Rose's description, a program of sympathetic attention to "a dimension of reality all the more important for the subject because it goes way beyond anything that can, or needs to be, attested as fact."[3]

If the word is granted sufficient latitude, almost all of Cristina Iglesias's work can be called screens. And almost all are shaped by the physical impression of other, prior objects. In some cases, the screens perform the primary function of occlusion, withholding from sight something too private or particular for general exposure. But they also arrest vision and detain it, rewarding sustained attention with concealed depths of their own.

The two chambers *Untitled (Eucalyptus Leaves II, III, IV)*, 1994–96, and *Untitled (Bamboo Forest II, IV, V)*, 1995–97, are made of aluminum, cast from dense stands of eucalyptus and bamboo. The walls are opaque, with tropical greenery forming a barrier behind the vertical stems. While even close inspection reveals no breaks in the metal foliage, at the softened corners of the rooms — the striated walls are made to bend like corrugated cardboard — there are discreet points at which the chambers can be entered. This substitution of physical for visual access is a variation on the usual purpose of screens. That is, there is more information available about the interior than even a permeable screen allows, but it comes at the price of disorientation: seen from inside, the space is experienced as elliptical, its boundaries softened and its limits hard to gauge.

Moreover, it is a space that is never seen empty. In another discussion of a psychoanalytic model of visual attention, Victor Burgin invokes an illustration from the final issue of *La Révolution surréaliste*. The image is assembled from little photographs of the Surrealists, which frame a painting by René Magritte of a nude woman who stands in for the missing word in the painted sentence, "je ne vois pas la… cachée dans la forêt." In Iglesias's bamboo and eucalyptus chambers, the spectator becomes (or constructs) the unseen naked woman in the forest, a figure who is vulnerable, disruptive, invisible. "In looking there is always something that is not seen," Burgin concludes, "not because it is perceived as missing — as is the case in fetishism — but because it does not belong to the visible."[4]

If these rooms sport with perception, they play on memory with equal vigor. For all their organicism, and despite minor differences — the vegetation varies

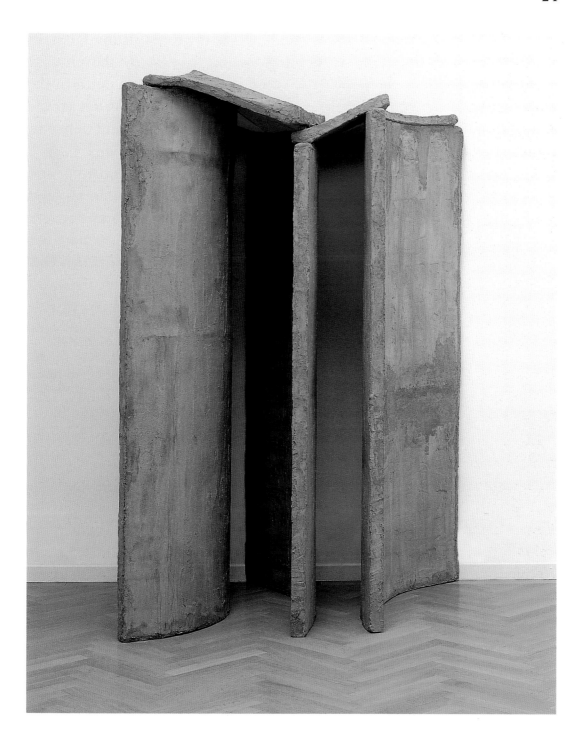

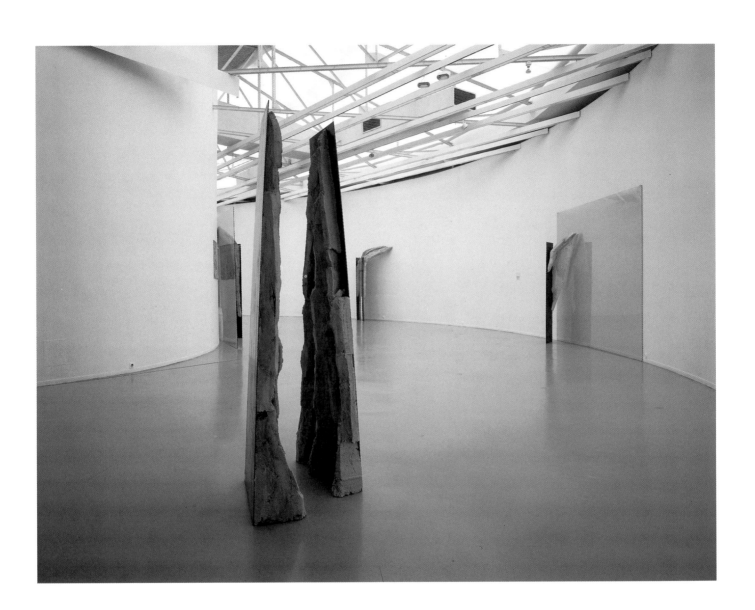

from eucalyptus and bamboo, and the configurations are not precisely the same — the two chambers are near duplicates. Direct comparison, however, is impossible, as they are meant to be seen in separate galleries within the museum. Verification of the relationship depends on matching a physical experience to a mental image. It is a perceptual mechanism also exercised, for instance, by Roni Horn's *Paired Field*, 1990, where pairs of small, machine-made metal objects, equivalent in mass but differently shaped, are displayed in adjacent rooms. The kinds of mental calculations Horn is interested in (as is Richard Serra) — estimated measurements of volume and weight and the physical behavior of objects in space — are not altogether foreign to Iglesias.

But Iglesias is concerned as well, or primarily, with extra information, with deliberately distracting data that skew perception of abstract form. Hence her introduction of details — as, for example, of identifiable and rather exotic flora — that can be called narrative, or representational. From a distance, as she points out, the textural incidents fall away, but the closer the viewer gets, the more consuming they become. In fact, Iglesias pushes this concern around another corner, to the intersection not only of form and image, but of image and decoration. She describes this conjunction as "taking ornamentation to a space of representation." The level of resolution, and of depth, in the casting fills in spaces usually left blank between what is necessary — in building a wall, or a believable image — and what is surplus. It is as if Iglesias were constructing a continuum, without apprehensible internal divisions, in which the organic world is connected on the one side to the realm of decorative pictorialism, and on the other to idealized abstract form.

This is true not only of the eucalyptus and bamboo chambers, but also of an additional installation, *Untitled (Hanging Tilted Ceiling)*, 1997, pages 138–39. It consists of a slightly canted dropped ceiling, just high enough to feel comfortable, and tilted, subtly but perceptibly, downward toward one far corner. Leafy and bright, it is nevertheless made of solid material, a mixture of powdered stone and resin: Tiepolo it's not. Indeed, this casting tends to lichens,

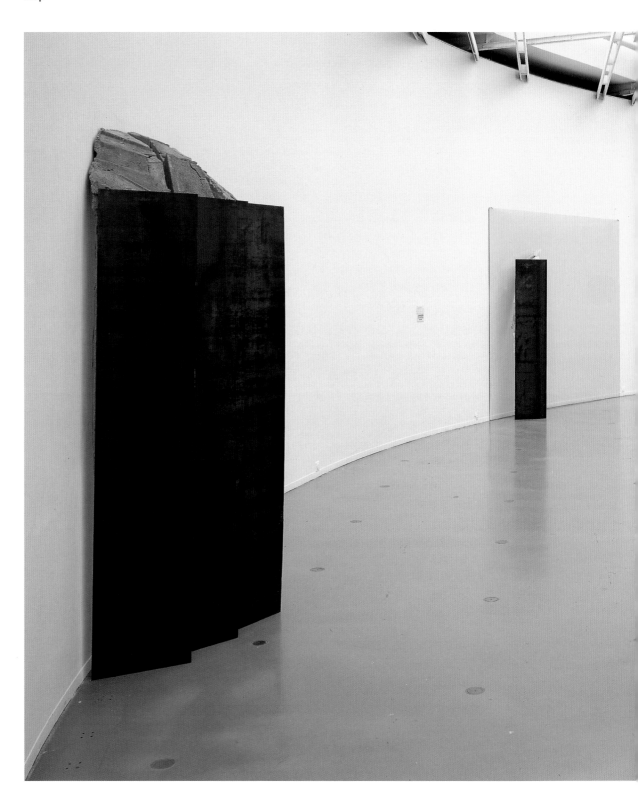

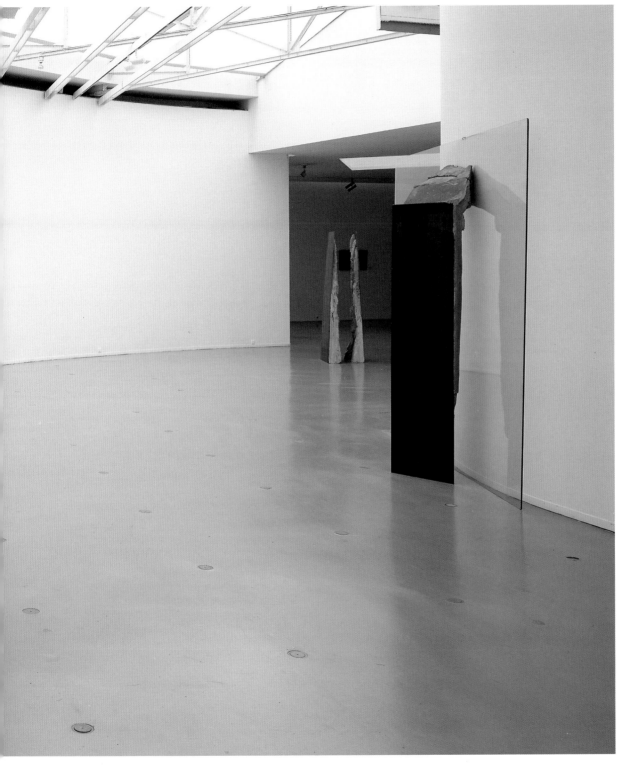

mushrooms, and mud: it is an impression of decay, not only as metaphor but as organic fact. With paradoxical precision and solidity, Iglesias delivers the boundary-blurring fade to gray now commonly associated with experiments in mechanical reproduction (as in the kinds of progressively degraded images that result from repeated photographic or xerographic copying, when each descending generation becomes the original for the next). It is her intention that viewers experience this room as both oppressive and dis-inhibiting — something like walking underwater.

A final installation *Untitled (Jealousy)*, 1997, page 129, is a chamber made of walls that are porous and thus visually penetrable, like ordinary screens. In Spanish, as Iglesias points out, the word for a louvered window covering is *celosía*, which also means "jealousy." (In French, such a window covering is a *jalousie*, a usage that exists in English as well, and which also translates as "jealousy.") The etymological associations are clear: the jalousie allows for shuttered surveillance, for watching without being clearly visible. Alain Robbe-Grillet's short novel *Jealousy* is constructed around just this connection; it is also built around detail observed with a punctiliousness rivaling that of Iglesias. With perfect impassivity, Robbe-Grillet's protagonist records his jealous surveillance of his wife, which is framed by a hypnotic series of slightly compromised views: the wife is seen through an unnamed French colony's banana trees, a balustrade, a set of French windows, and, as the novel reaches its most interior space, a set of louvered blinds, described in several paragraphs of fanatic minutiae.[5] Also a favored visual motif of film noir (which was contemporary at its height with the *nouveau roman*), the jalousie notoriously works both ways, its photogenic play of light and shadow sometimes more revealing of the seer than the seen.

Intrigue and exoticism, menace and suspicion, dubious protection: these associations to the semitransparent screen are all in some measure relevant to Iglesias's screened room. It is designed to permit viewers to see in, not out. Foliage and a barely decipherable text constitute its patterning. Like the dropped ceiling that conditions the viewer's experience of the installation

beyond it, this screen is meant to be a break, or blind, for what follows: it is a recollection — of the words and objects cast into its surface — and also a presentiment.

Screens and blinds, memory and anticipation, ornament and representation have been consistent concerns in Iglesias's previous work. The last of these, the interest in the shared limits of decorating and depicting, have perhaps their clearest expression in a body of sculpture involving salvaged tapestries. In *Untitled*, 1993–97, page 73, a tapestry appears shadowed by an aluminum sheet; in *Untitled*, 1987, page 69, it is pinned to the wall behind glass propped up by a colossal finger of iron and concrete. In *Untitled (Venice I)*, 1993, page 64, a tapestry is fixed to the backside of a massive slab of concrete, which stands close to the wall; here, the tapestry is seen only obliquely, reflected in a half-hidden sheet of glass. A premier vehicle for artistic expression in medieval Europe, tapestry has also been, of course, a functional form, meant at first to help warm drafty stone castles, where it was hung on the walls, but drifting also, especially in northern Europe, from wall to floor to tabletop.

In its indeterminacy — does it hang (as a representational artwork) or lie flat (as functional form) or occupy some less fixed, decorative position? — lies tapestry's value to Iglesias. She selects old but not especially valuable examples, in which floral motifs predominate. The penetration of stone walls by vegetation figured in these tapestries has, of course, often been overtaken by historical reality (when, for instance, medieval stone structures deteriorate), and Iglesias's work also plays on this metaphorically potent example of exposure and loss. In her tapestry assemblages, frames overtake images, and weight-bearing structures are fragmented or otherwise rendered precarious, so the relationship between support and image (or decoration) is troubled or reversed.

Louise Bourgeois, whose parents owned a gallery specializing in tapestries, has recalled, "The tapestries were always torn at the bottom. They were originally used as moving walls ... the feet on the figures were often

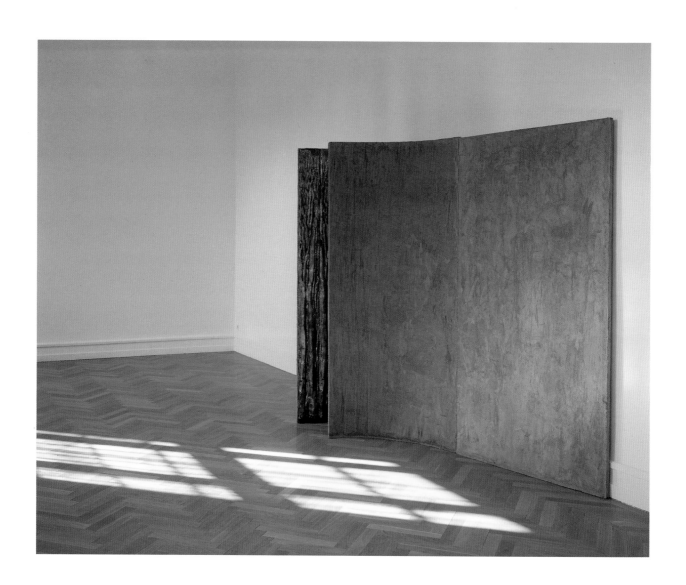

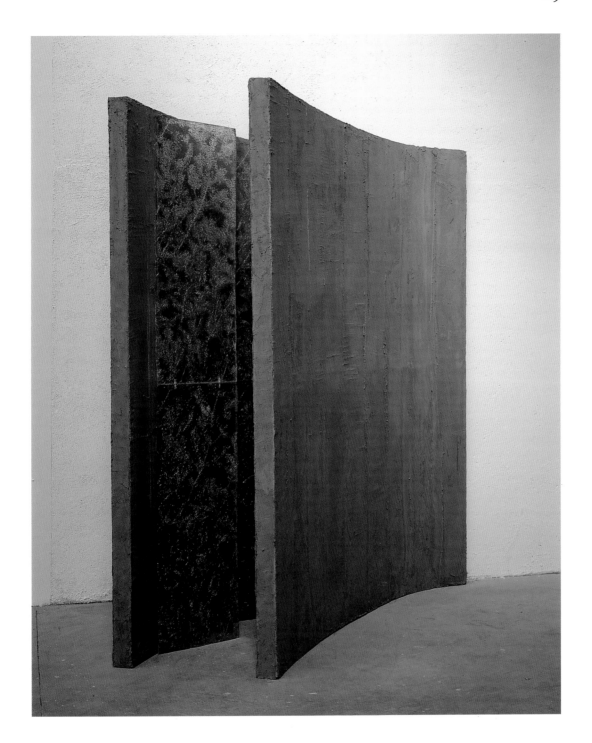

missing. ... I became an expert at drawing feet. ... I was very satisfied with them. ... It was a great victory. And it also taught me that art is interesting, and that it can be useful, which is completely unknown today. ... That is how my art got started."[6] Her statement is a wonderful description of physical instability restored, of form and function resolved, and it is — like all the narrative foundations of Bourgeois's work — at least part fantasy. Iglesias, in a sense, demythologizes Bourgeois's tapestries, returning them to foot-lessness and fragmentation, to a position where utility is contested though not unequivocally denied, just as both figuration and ornament are present but held in abeyance.

There is an additional role in Iglesias's work for screens and memory, in the creation of photosilkscreened metal and glossy silk panels. Ever since Robert Rauschenberg transferred photographic media imagery to canvas with silkscreens in the early 1960s, the process has served as a means of expediting representation — of making pictures with a minimum of expressive gesture or technical virtuosity. The silkscreen, a porous matrix, permits limitless reproduction; quality is unrelated to priority in the sequence of production. Iglesias has used the medium to project photographs of forested landscapes, and also of maquettes of her metal screens, onto flat panels.

Spatially, the latter are especially complex. A pronounced illusion of depth is created by the recession of the rippling walls, which are generally positioned to suggest a corridor leading away from the picture plane, but this opening into space is opposed by the physicality of the support. (Even the silk panels, stretched around fairly thick frames, have a substantial presence: in fact, the photographs continue around the sides.) The spatial profiles of the photographed walls can be gauged by reference to the shape and size of Iglesias's sculptures, but this reference is also misleading, since the photographs are in fact greatly enlarged images of much smaller models. The shift in scale is visible in the texture of the depicted surfaces, where bits of leaves and stems assume impossible proportions. These, the work's only index of the world outside the studio, seem the most fantastical.

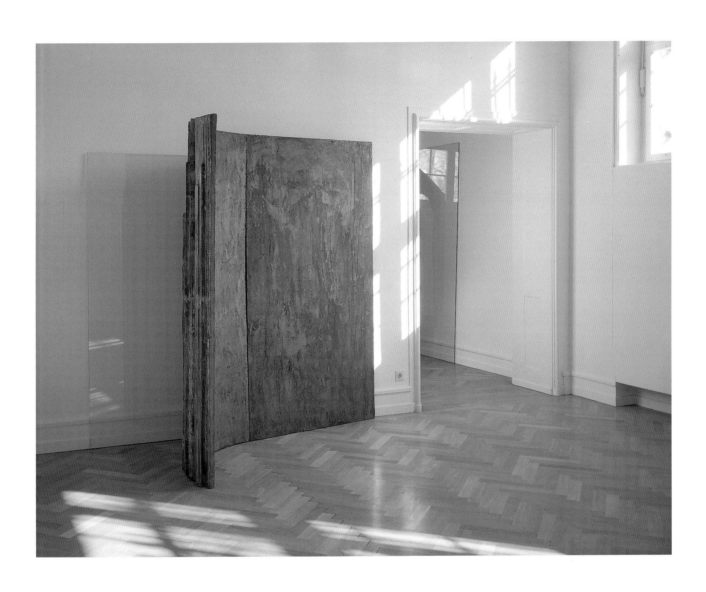

Referring reliably neither to nature nor to art, picturing passageways that are doubly and triply shielded, these screens offer themselves as memories of experiences that never existed. As visual dwelling places, they are the more inviting, and the more rewarding as objects of analysis.

1. "The Psychology of Everyday Life," in *The Basic Writings of Sigmund Freud*, trans. and ed. A. A. Brill (New York: The Modern Library, 1938), p. 62.

2. "The Interpretation of Dreams," in ibid., p. 243.

3. Jacqueline Rose, *Sexuality in the Field of Vision* (London: Verso, 1986), p. 13.

4. Victor Burgin, *In/Different Spaces: Place and Memory in Visual Culture* (Berkeley: University of California Press, 1996), p. 66.

5. For example, "Once the bedroom is empty, there is no reason not to open the blinds, which fill all three windows instead of glass panes. The three windows are similar, each divided into four equal rectangles, that is, four series of slats, each window-frame comprising two sets hung one on top of another. The twelve series are identical: sixteen slats of wood manipulated by a cord attached at the side to the outer frame. The sixteen slats of a series are continuously parallel. When the series is closed, they are pressed one against the other at the edge, overlapping by about half an inch. ... When the blinds are open to the maximum, the slats are almost horizontal," and so on, for another full paragraph. (Alain Robbe-Grillet, *Jealousy and In the Labyrinth*, trans. Richard Howard [New York: Grove Press, 1965], pp. 119–20; this edition shows a man peering through a jalousie on the front cover).

6. Donald Kuspit, *An Interview with Louise Bourgeois* (New York: Vintage Contemporary Artists, 1988), p. 20.

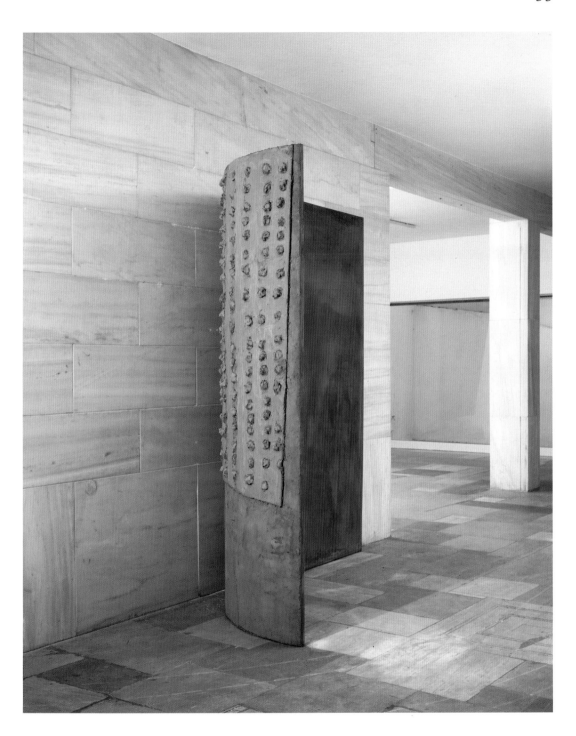

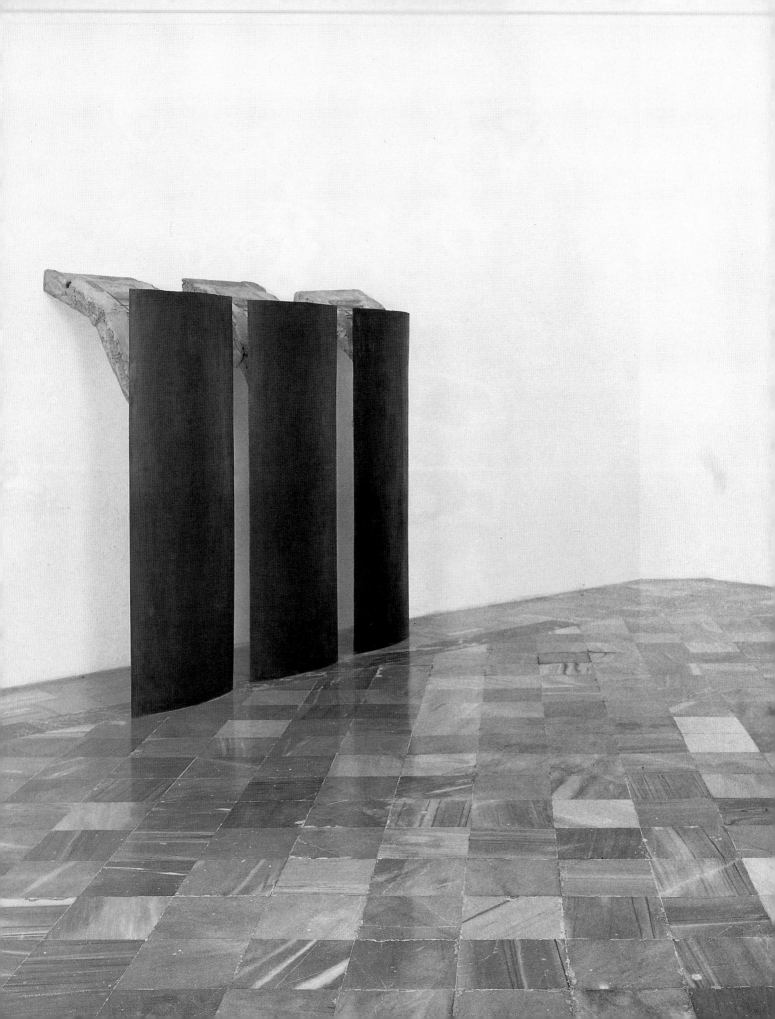

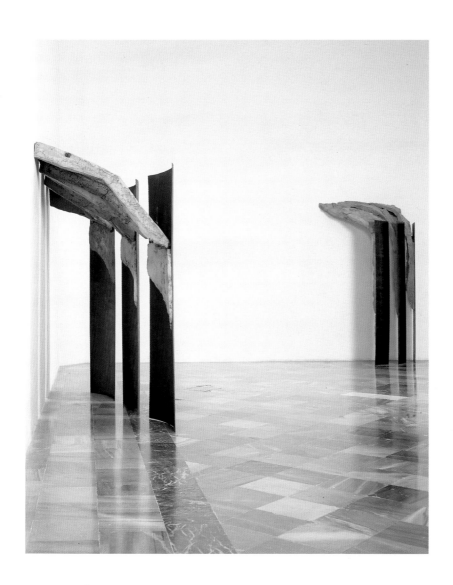

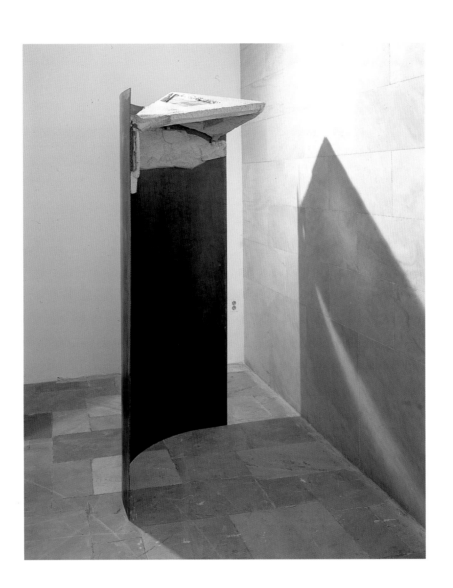

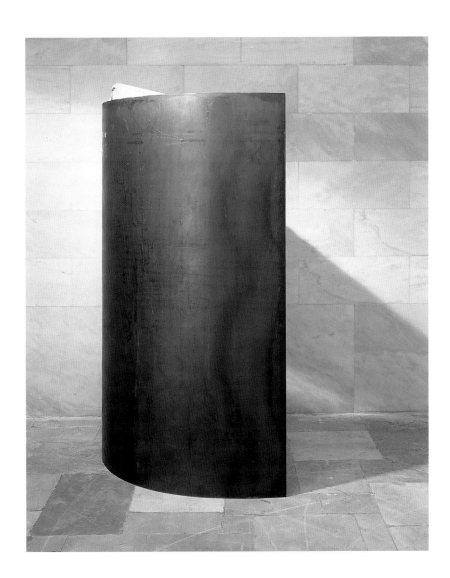

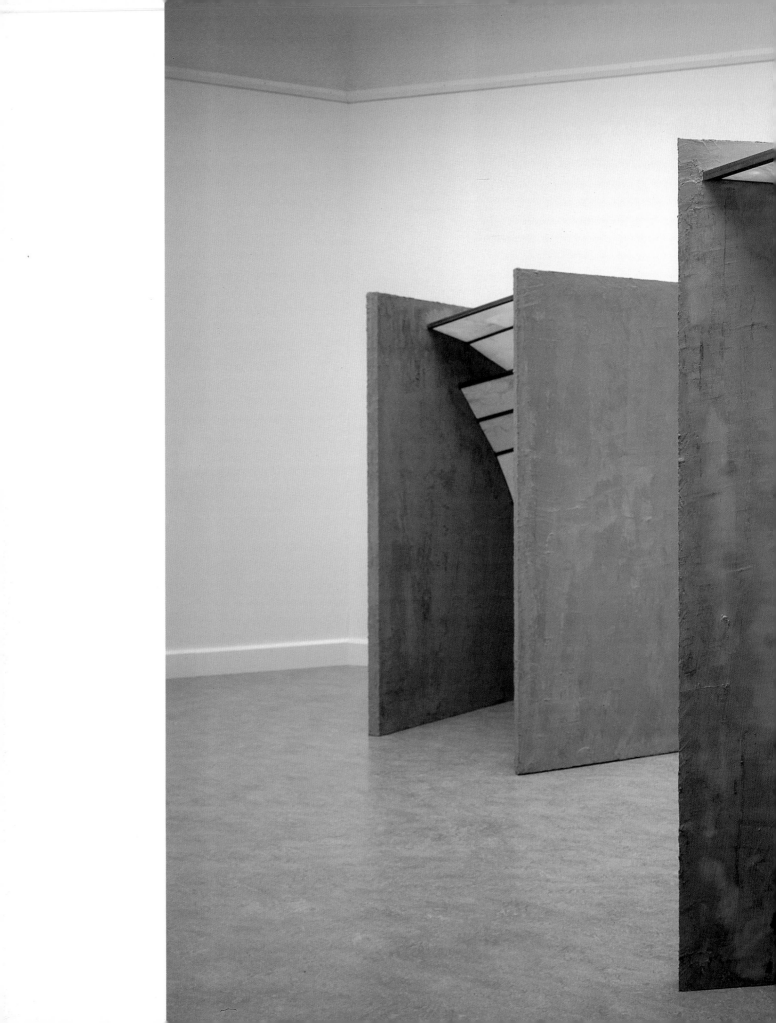

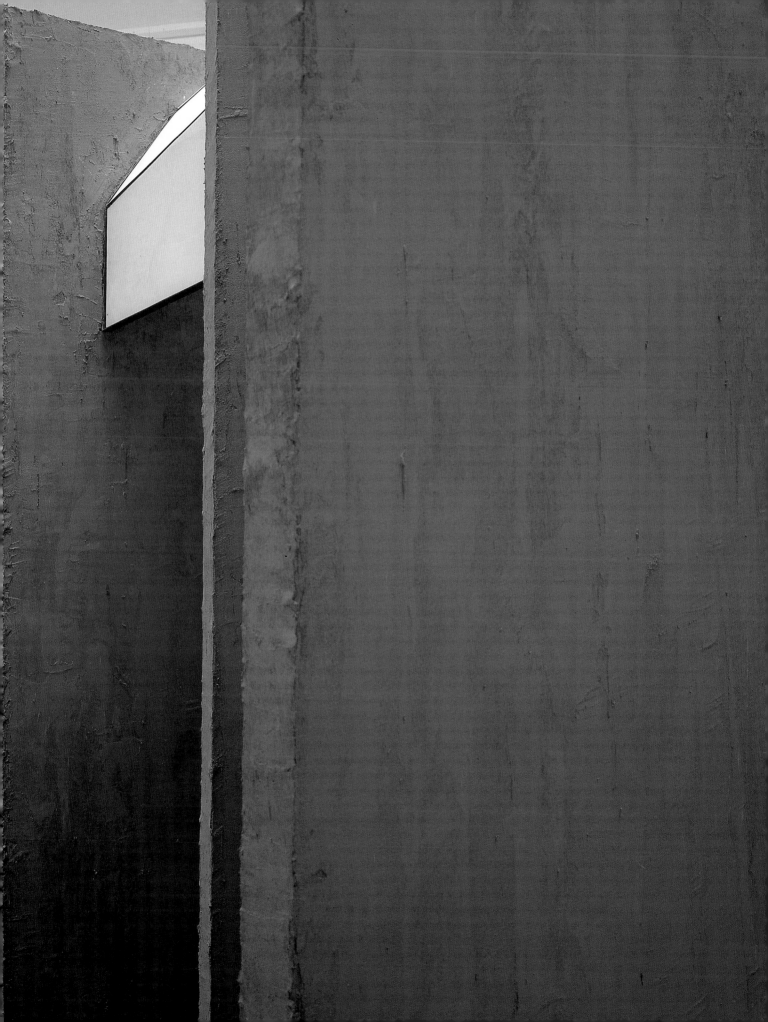

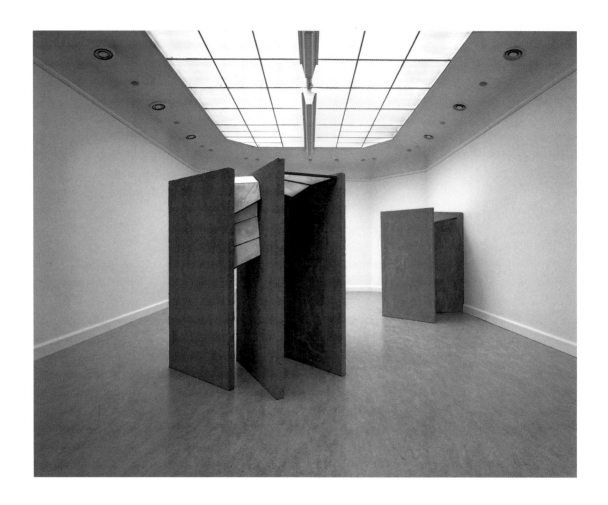

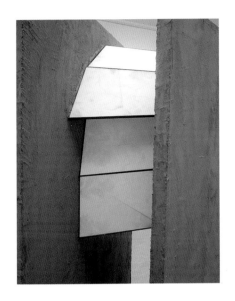

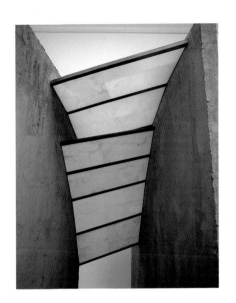

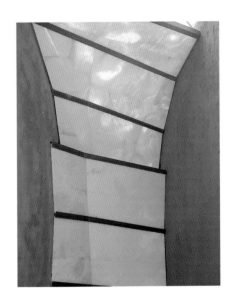

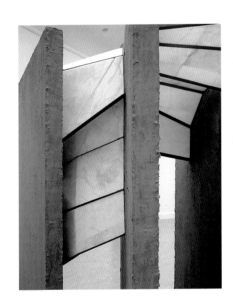

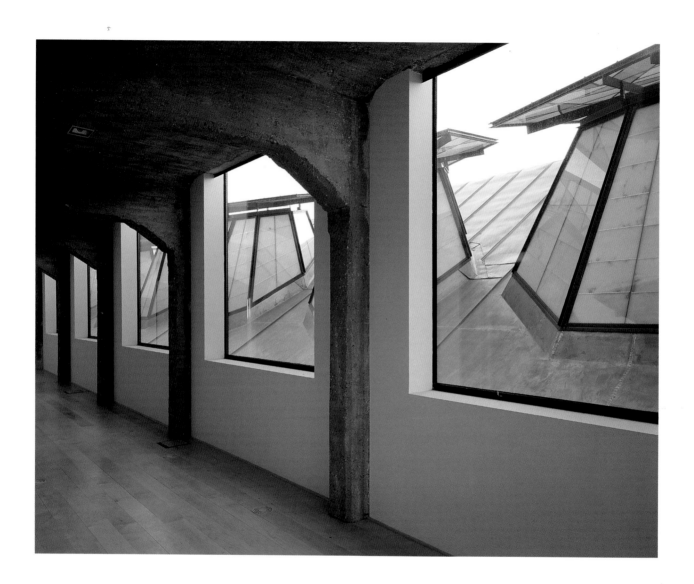

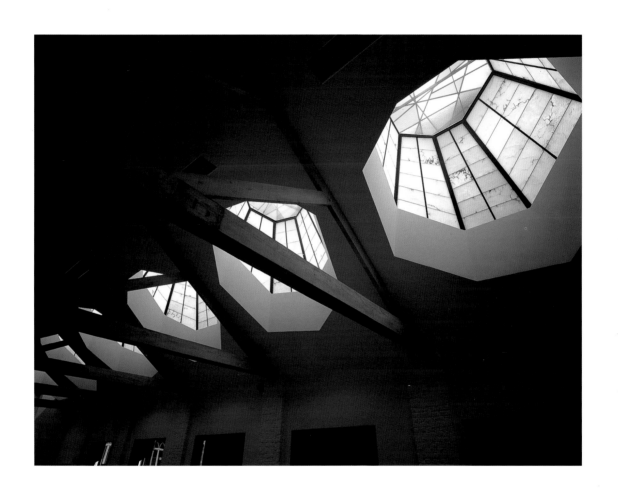

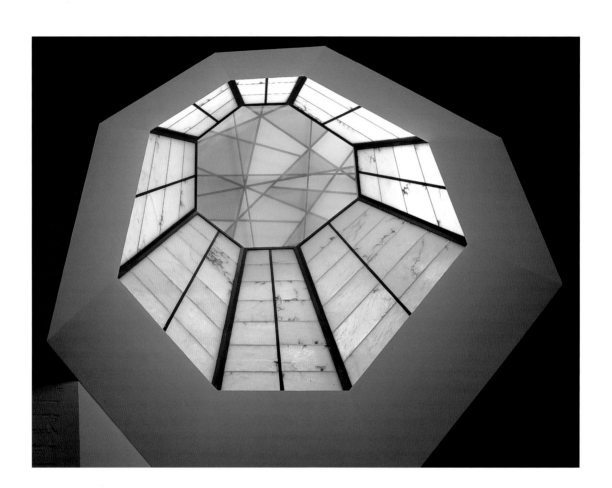

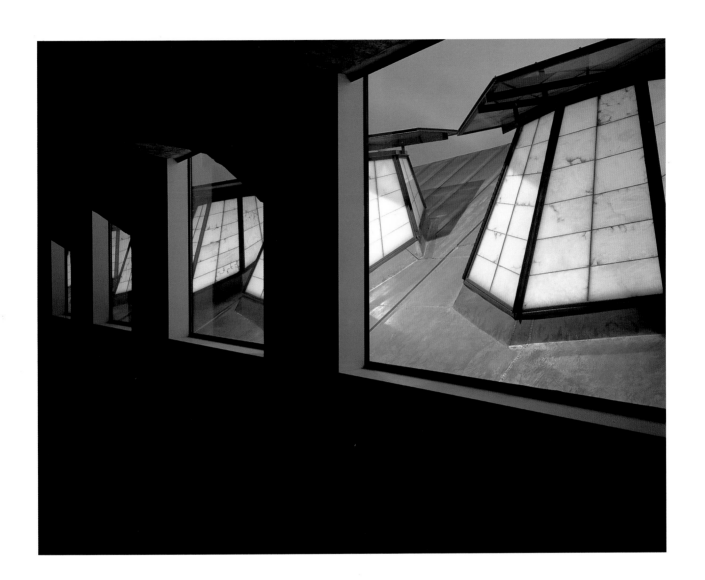

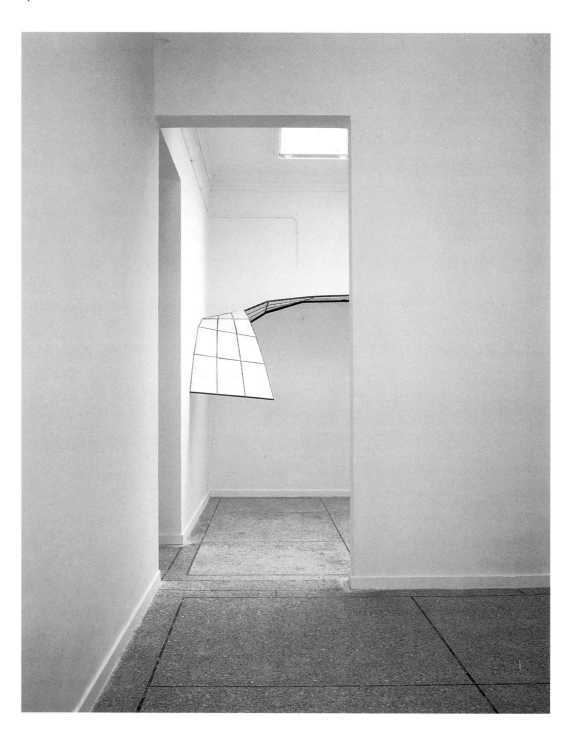

STAINED
WITH A PALE LIGHT

ADRIAN SEARLE

Cristina Iglesias works at a table in her studio, constructing the most precarious model from a few insignificant scraps: bits of wood, tracing paper, pins, tape, little lumps of clay and plaster and torn-off strips of cardboard. Using things near to hand as a stage designer might, to construct a theater of the mind from photocopied backdrops and flats, painted screens, printed forests. Inventing a space.

Trying things first one way, then another. Playing with a piece of mirror, to duplicate and reduplicate and multiply the scene she's made. This has the effect of both enlarging the visual space that this tabletop construction contains, and complicating, by way of a simple illusion, our perception of where things are, what is real and what is reflected — enlarging the space, reducing the possible

sightlines, making this fabricated world appear to grow deeper, then more shallow again. Building a territory.

What Iglesias has constructed in miniature — a series of columns, a lean-to, a flimsy paper canopy on a cardboard wall, a number of grayed and striated planes abutting one another and jutting into a blank white cube of space — will later be photographed in close-up. The world will be cropped by the lens, and the photograph will make it almost impossible for us to tell how big the space is, how tall the objects, whether what we are looking at is large or small. The close-up might appear to be a model for a sculpture or an architecture, an invention, or it may strike us as somewhere that we have already been: the interior of a building; a colonnade discovered on some meandering journey through unfamiliar streets. A skidding view of trees, glimpsed as we drove along the highway; a clearing in the woods.

The close-up has become a blowup — and suddenly, we are no longer certain how big we are, whether this scene can be walked into, crawled through, or entered only by the eye. What began life amid the clutter and rubbish on Iglesias's studio table has become an entrance to the imagination, a passage, an invitation, leading us somewhere and nowhere.

All this is much like play; like a child's solitary invention, down on hands and knees in the dust, down among the weeds and dirt and leaves, using whatever comes to hand, creating a new corner of the world, both as a model and something in itself.

A child's fantasy and play and the artist's work are not unconnected, although the adult consciousness disguises these flights of the mind, or chooses to forget their origins. Ask artists about their work, and what leads them to make what they do, and the best answer is likely to be the work itself, and another work, and then another. These repeated acts, at once the same and yet distinct in their form and appearance, also become part of the viewer's journey — from one object to the next, from one place to another. They are a succession of trials and discoveries, gains and losses. All are flights away from, and into, the present.

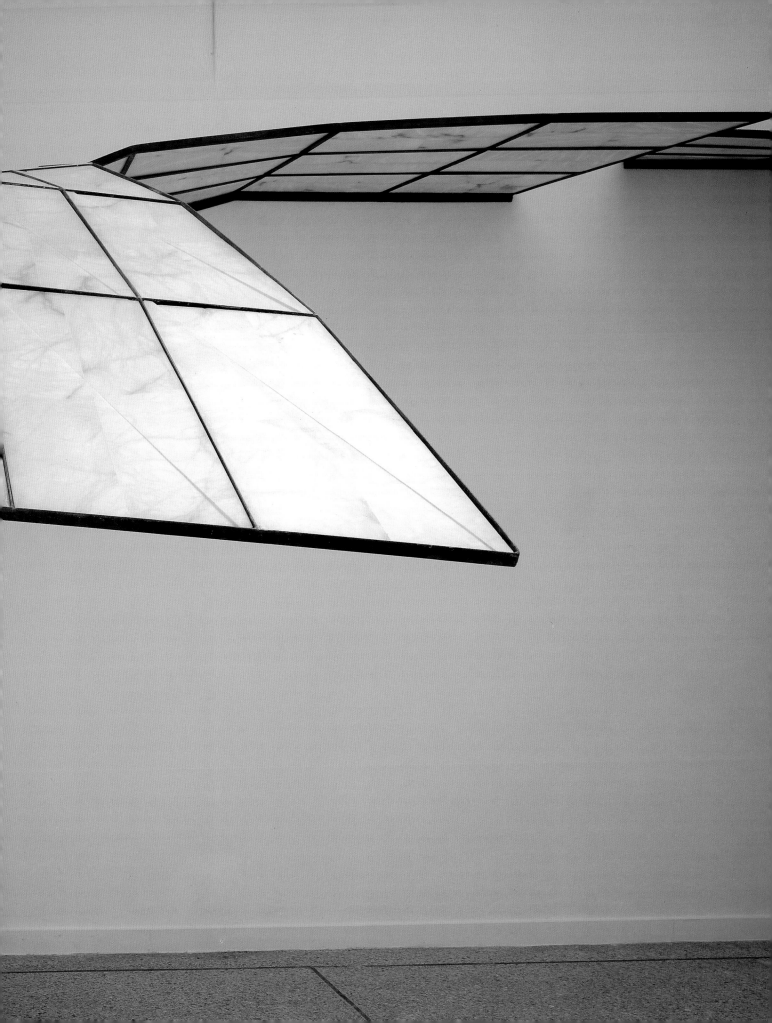

Iglesias's sculptures are both objects and places. They present themselves to us in terms of volumes and multiple surfaces, as constructions, fabrications, proposals. They present themselves to us in the manner of the most familiar details of the spaces we occupy and move through every day — arrangements of walls, canopies, grilles, concatenations of verticals and angles, bulks, wedges, and shunted, narrow spaces; planes and corners, barriers and sudden openings.

The experience of her work is like a walk through the world, coming across street corners where an alley sidles into the square at an oblique angle, an alley you wouldn't know was there unless you were right on top of it; and then a high wall covered in ivy, the blind wall of a building, a glimpse of a darkened room through a gap in the shutters, light falling through a stairwell, a skylight, the invitation of a half-opened door. Those places where we have stood or passed by, a memory of somewhere, the recollection of a place that has already begun to fade and unravel, like an old tapestry. Where was it, exactly?

Aligned in a subtle relation to the walls and floors and ceilings, Iglesias's works enter into a kind of collusion with the limits and proportions of the spaces they come to inhabit. But rather than augmenting a given architectural void, decorating it, or filling it up, they change it. With their architectonic forms and their sometimes profuse allusions to the natural world, to husbanded vegetation and to nature run riot, they alter the way in which we regard their settings. It is a matter of outsides and insides, openness and containment. The structures she builds are mostly enclosures of some kind — cul-de-sacs and screened, hermetic corners, impasses.

The work redirects us, slowing our progress, halting us at a wall, which is also an image of a wall, directing us to a space, a narrow space between the wall Iglesias has erected and the wall of the room in which her work stands, a space which seems no longer to belong to the everyday order of things. We might see the work as a matter purely of shadows and of available light. A solid mass fills a room with its atmosphere, its sullen weight, the glints and

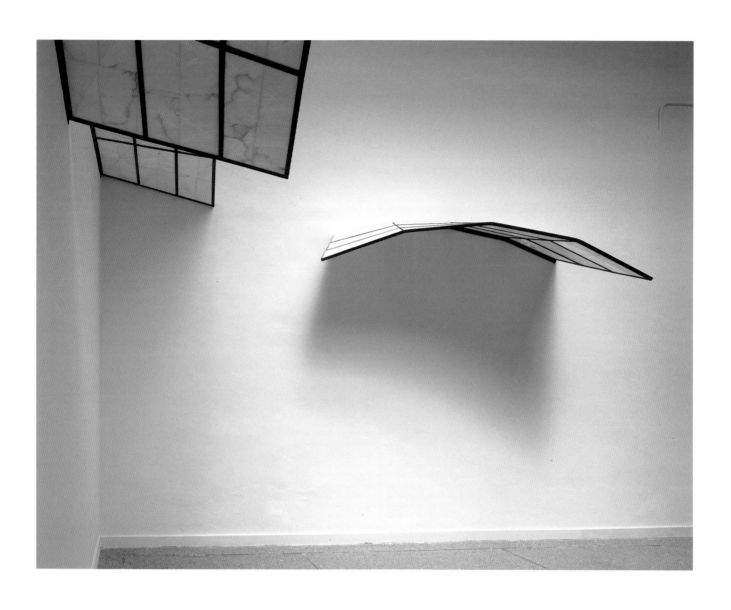

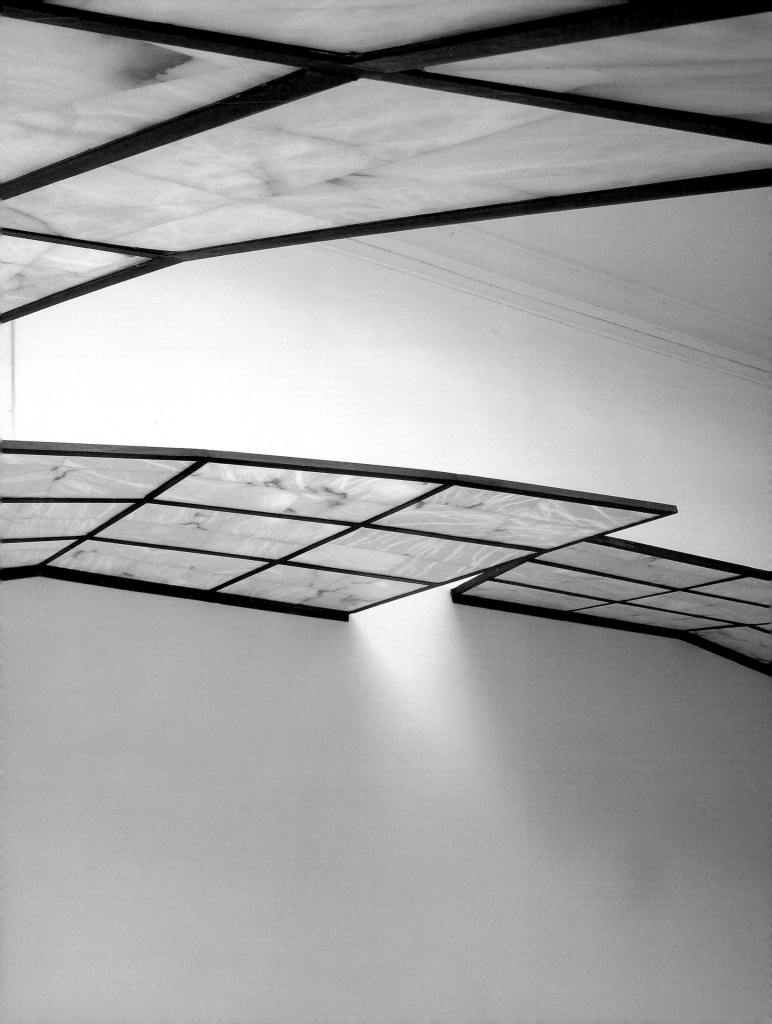

hollows and indentations running across its face. How obdurate it is, how it endures us.

Iglesias's work is no longer a model on a table. It has become an incident — a sequence of incidents — in a gallery. The plane on which we stand has replaced the tabletop. We might stand under one of her canopies, a canopy which serves no ostensible purpose. It is fixed to the wall of an enclosed room, safe from the elements. There is, after all, no rain nor is there likely to be. The day is not too bright, we've no need to protect ourselves from its glare, there's no wind. There is nothing to detain us, but we stand there anyhow. We stand there just for the pleasure of being under a different light, a light filtered by the pale translucent alabaster of the canopy. We stand there for the pleasure of the wrap and curve and stretch of it, to feel its gesture of embrace. There's no other reason to be here, other than for the moment, standing under the canopy in the cool alabaster light.

Iglesias appears uninterested in such issues as "truth to materials," and undaunted by taboos against ornamentation, or the flagrant use of decorative effects. Her use of disparate materials — which are sometimes what they seem to be, sometimes not — is agglomerative, heterodox, and impure.

Standing under the hulk of a false, canted ceiling Iglesias has constructed, I look up at the whorls and tracery of its plaster surface. The surface is dense, churned, proud with innumerable casts taken from the undersides of fungi; embedded in it are the patterns of broken stems, the radiating bursts and filigree of delicate mushroom gills. It is like looking at the cratered surface of the moon through a telescope, or at the ceiling of some vegetal or mineral cathedral, with its roundels and bosses, at a chalk cliff embedded with fossils.

The only way to really study this broken, agitated surface is to lie down under it, like some stone king in an apse, with a carved dog at my feet, feeling the weight of things. Who is to say what kind of engagement is permissible, what kind of confrontation matters?

Or we might stand in the narrowing angle she has created between one

plane and another, between a cement wall and a sheet of glass. To insinuate ourselves into a space designed not for entry, but only to be looked into. To stand right up close to the sheet of glass that stands behind the arc of false wall, only to watch the reflections in the glass, and at the image of brownish tapestry stretched against the glass itself, an old tapestry of ornamental trees and pale vistas, an embroidered eighteenth-century country park.

There are no figures in Iglesias's work. The viewer, of course, is the figure the work always begs, the figure the work always seems to be for, the figure that is always absent. The spectator, moving between these different surfaces and materials, becomes part of their articulation.

It is all a matter of how to exist with an artist's work. Its specific and concrete facts — materiality, construction, formal order, and fine adjustments — are the syntax and grammar of our conversation with it. The language of sculpture is also the language of buildings, other kinds of objects, trees and bodies — even our own bodies. But we are not statues.

Standing close to the thick, angled walls, surrounded by walls, with their endless repeated encrustation of leaves, standing so close that it entirely fills my field of vision; so close, in fact, as to be able to notice the dust building up in pockets and around the contours of the relief, and to smell the faint reek of resin. Losing myself in this clump of stems, this hedge of foliage, as though my head were in a thicket. Standing so close that its detail becomes endless and engulfing, mesmerizing and visceral. Passersby will think I'm crazy, standing there like that. But for a moment, I am lost in this other place, I have become invisible, even to myself, hidden among leaves.

How difficult it is, just to be where we are, to be nowhere else but here, without straying, without leading ourselves astray on some mental flight away from where we stand, away from the present. Iglesias's works are incidents in a room, unchanged except by our presence, by our coming and going, by our departures and returns. We watch other people, appearing and disappearing as they walk around and between the works, going from one space to another. Watching them pass, held for a moment in silhouette

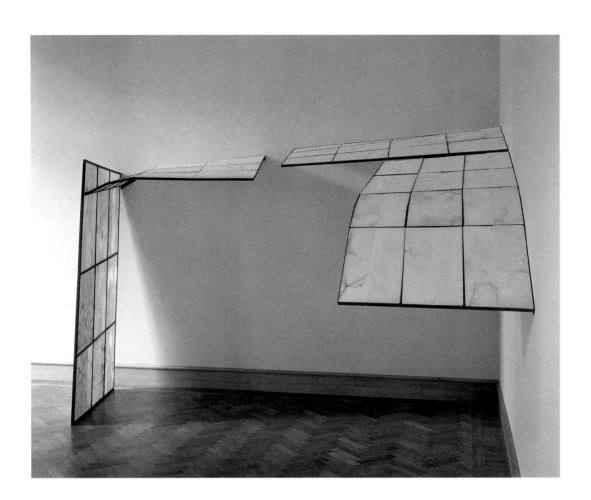

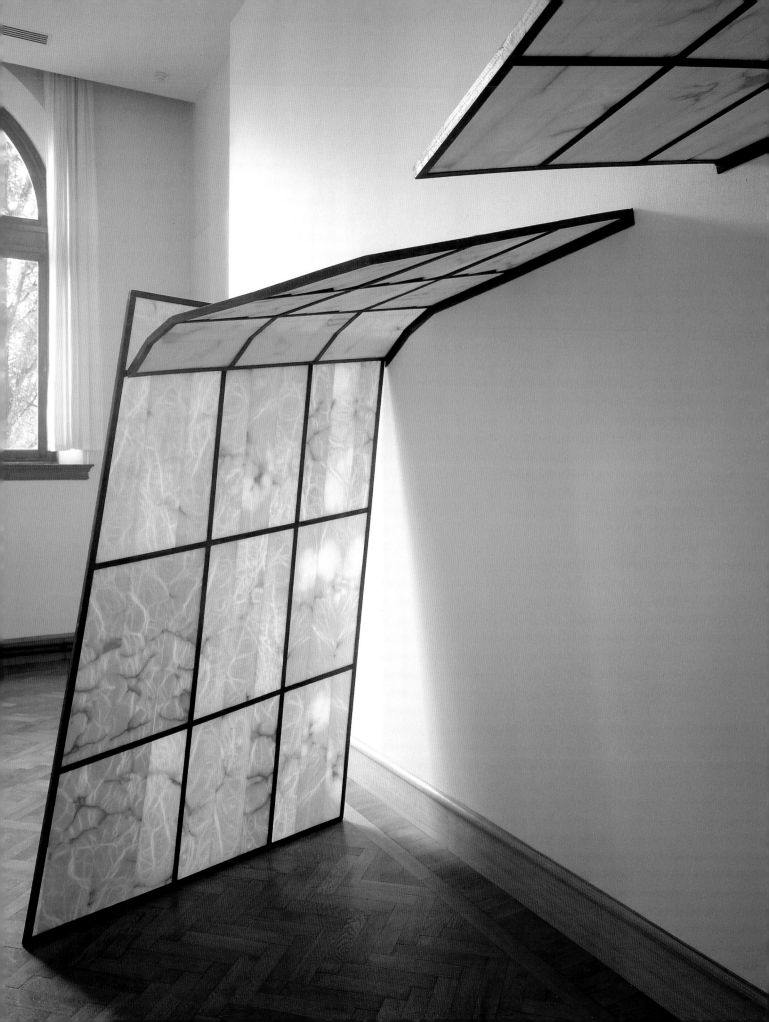

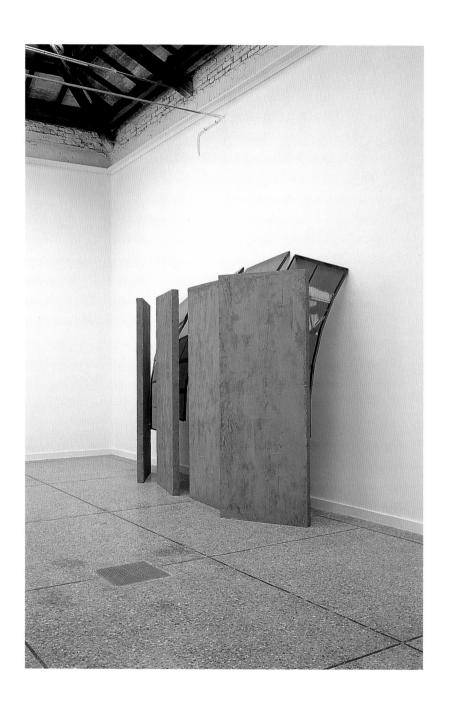

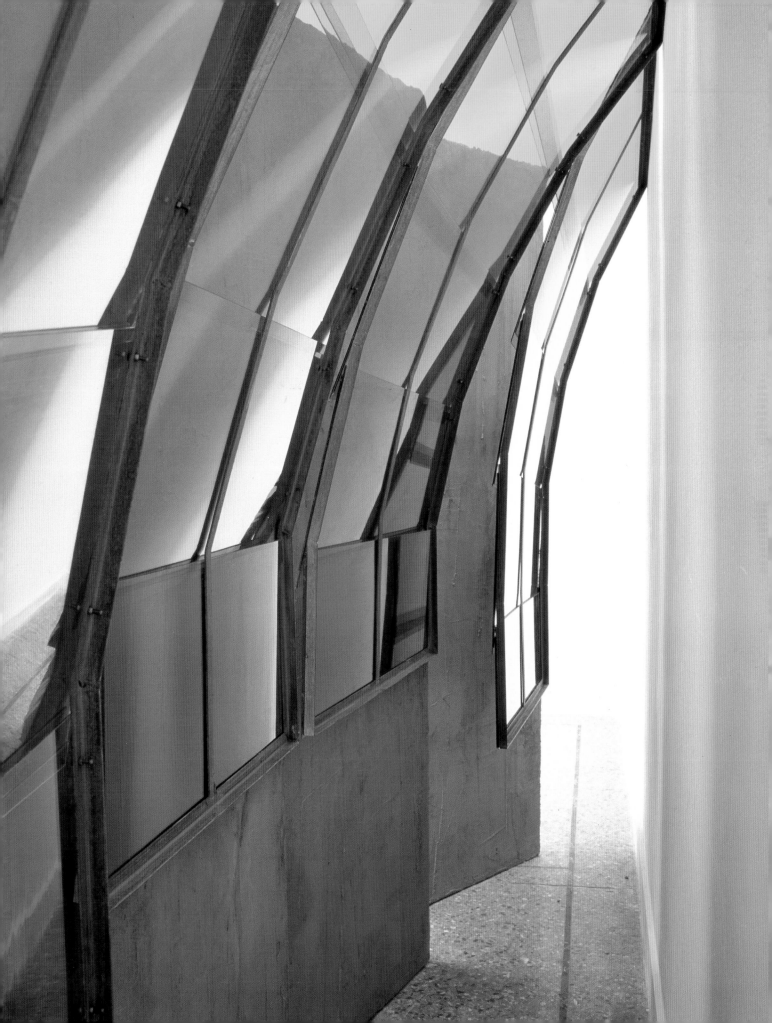

against a white wall, oblivious as they stand and look, turning away, walking on. Hearing the footfalls of unseen feet behind us, just as we had begun to feel that we were utterly alone in the room, in solitude with ourselves. They bring us back to the present moment.

Iglesias's work has been described in terms of the labyrinth. Labyrinths are designed to mislead, confuse, and ensnare. The pleasure of a labyrinth or maze is the pleasure of losing ourselves, of becoming lost and of refinding our way. What concerns us as viewers, and what gives us pleasure, is our own passage through the work. And we can go which way we like, and the heart of the labyrinth is never in the same place twice.

There's an old joke: A traveler, lost in the countryside, stops and asks a local man the best way to get to his destination. "Well," says the old man, "If I were going there myself, I wouldn't start from here."

Unlike journeys, or poems, or movies, sculptures and images have no beginnings, and no destinations. They have no ends. Their openings, and their resolutions, are contained within and between them. We journey back and forth, make detours, find ourselves delayed, expect to arrive in one place only to find ourselves elsewhere. We are constantly in motion between one place and another, and there's no way back to a beginning that is forever receding into the distance. Iglesias's work is about standing still and walking, about being detained, enticed, arrested, allured, and captivated by a subtle geometry of space and objects revealed not by plumb lines or tape measures or by bumping into things in the dark, but by consciousness. I am in a place that is not a place, beside a wall that is not a wall, at a destination that turns out to be merely a stop on the way. Everything is contingency. Striving to *be there* while in endless transition through an interminable succession of moments, is a struggle with our constant evasions.

If I describe the work that Cristina Iglesias makes as a space, or as a place, a territory, an opening, or an enclosure, or even as an incident in a gallery, I also see it as a situation, a mental as well as physical situation of forms, images, allusions, references, and presences. The work's sensitivity to chang-

ing light, to the vagaries and conditions of its surroundings and circumstances, even the sense of time and duration it contains — one can never see the entirety of a work at one moment, parts are withheld, and one often has the feeling that there's more going on and more to see than one has taken in — all add to the sense that the work's plenitude is endless, that it demands our return, to be seen again, missed again, approached again in yet another way. The situation is constantly changing. Even though everything is static, nothing is in the same place twice.

And so it is with memory, the memory of places and situations, the memory of a stand of bamboo or a Moorish screen, the memory of a street, a window, a doorway, the memory of a certain kind of light, a shelter, a history of feelings. The unseen history of Iglesias's work might begin with such things, long before the key is turned in the lock of the studio door, and before she goes to sit at her table. Sitting at my own table I close my eyes and see an avenue leading away in a white room, shards of bark and eucalyptus leaves underfoot, a wall ahead and a shadowed space. When I stretch my hand out it is stained with a pale light.

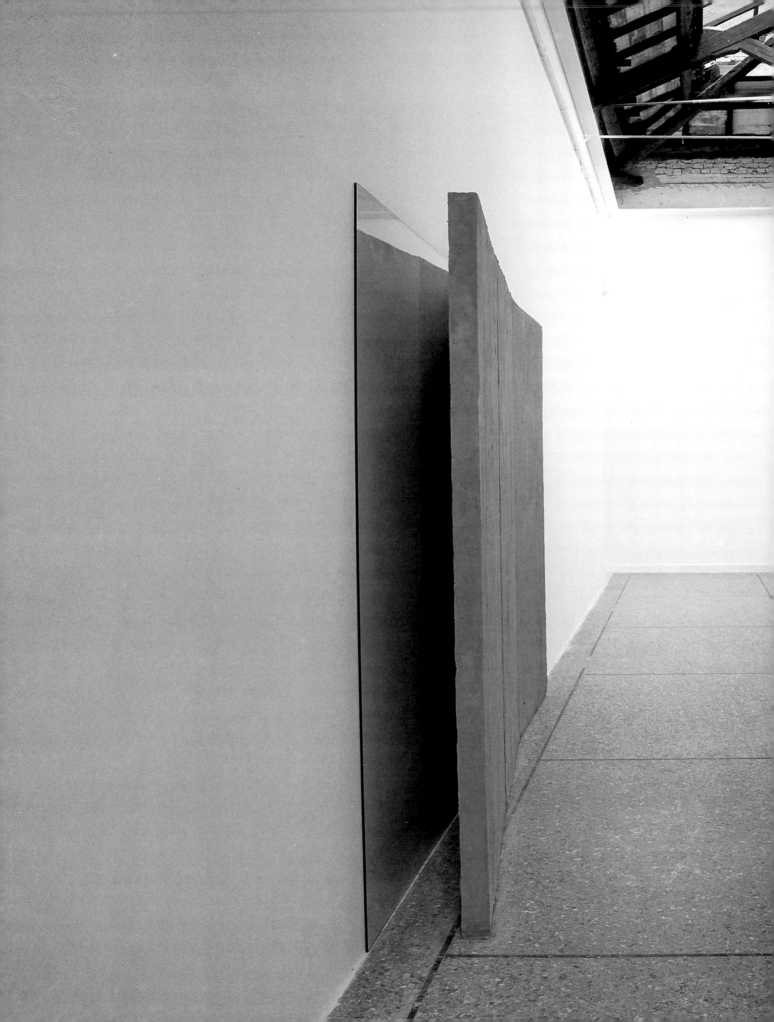

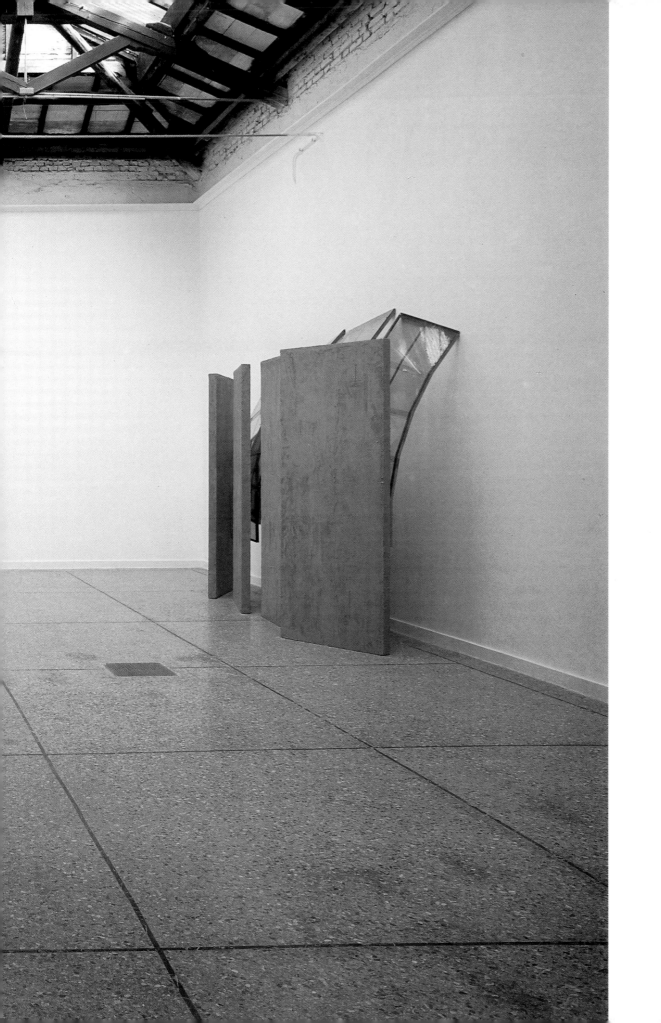

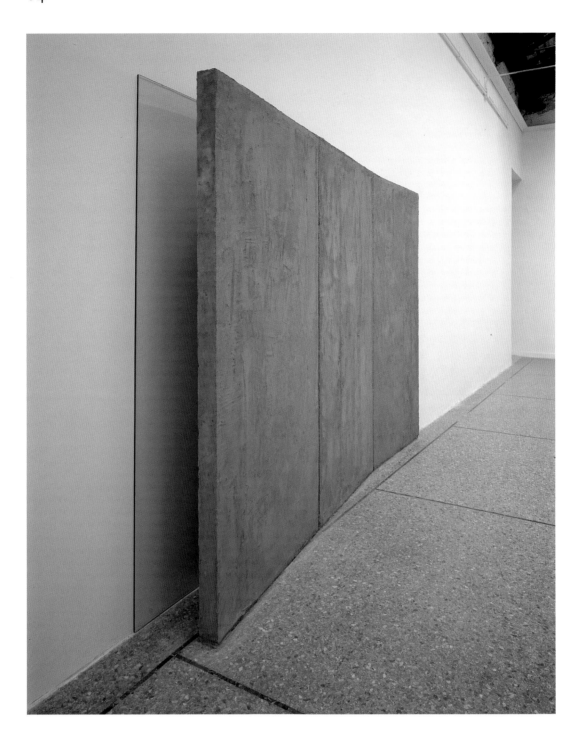

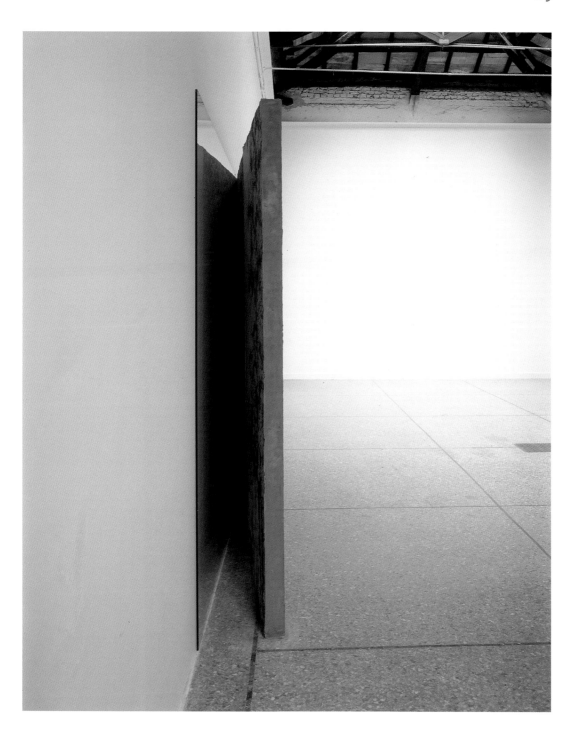

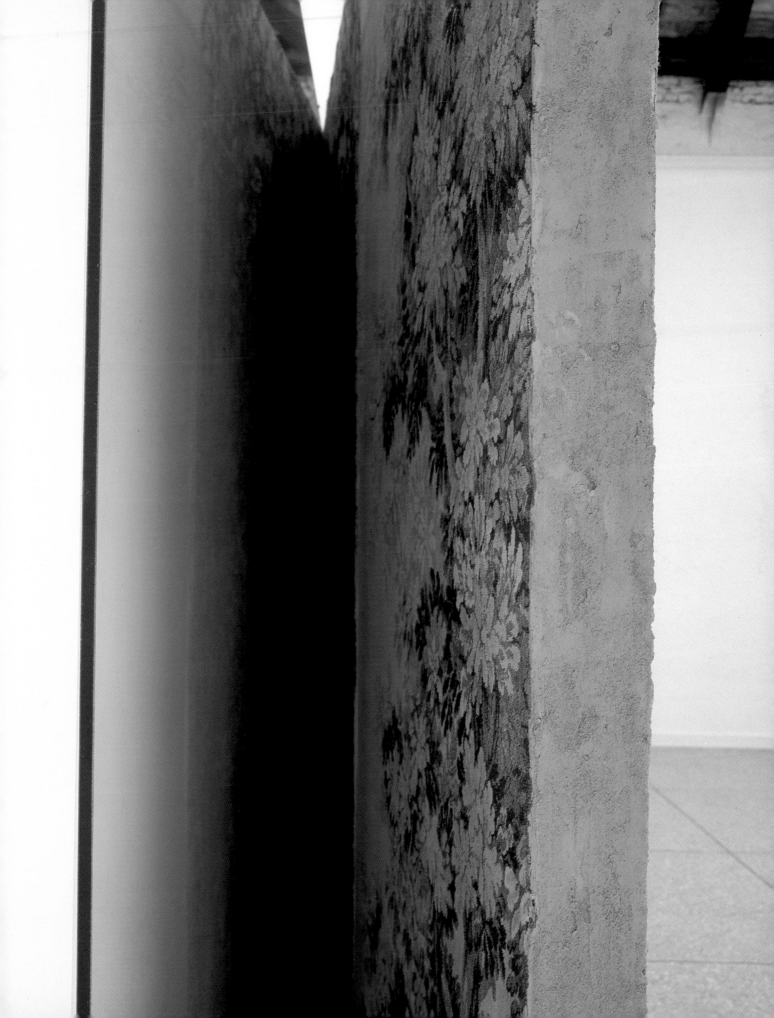

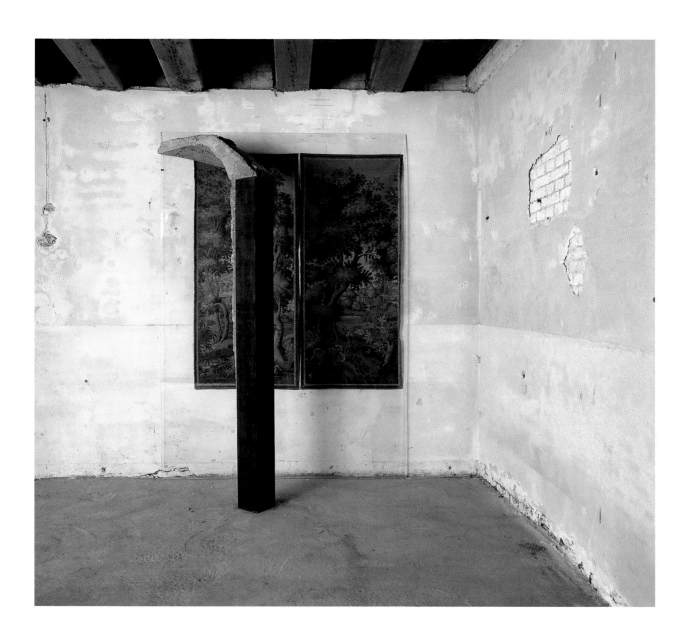

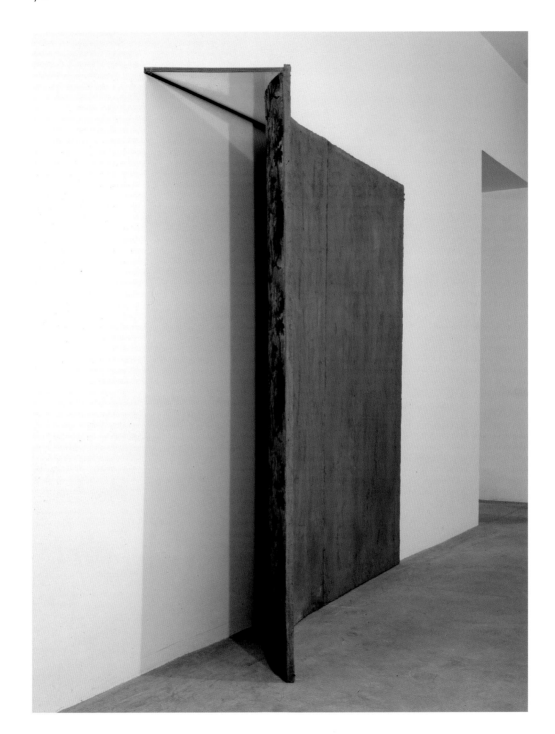

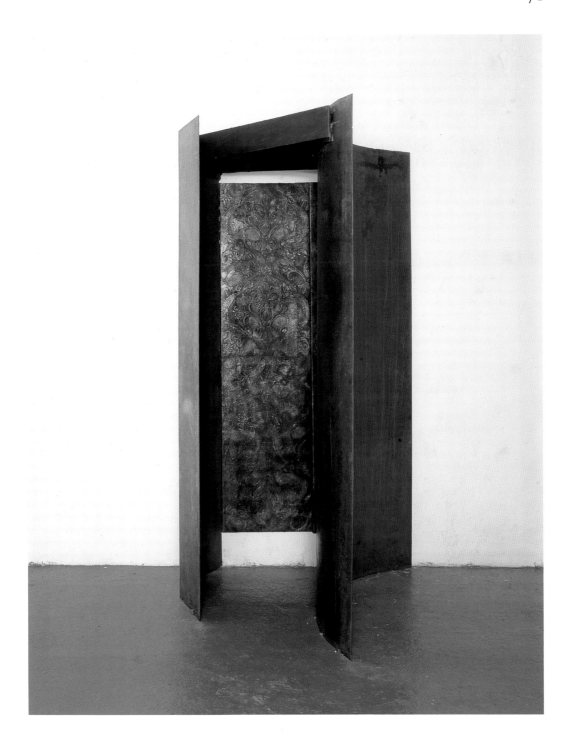

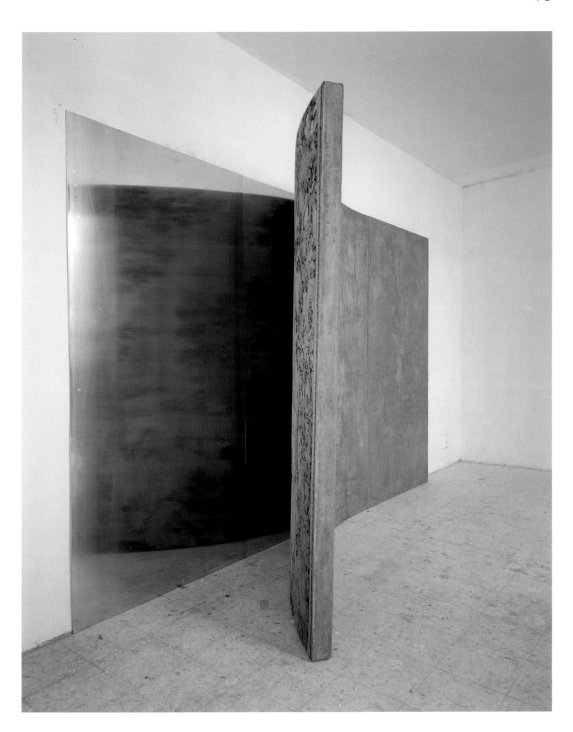

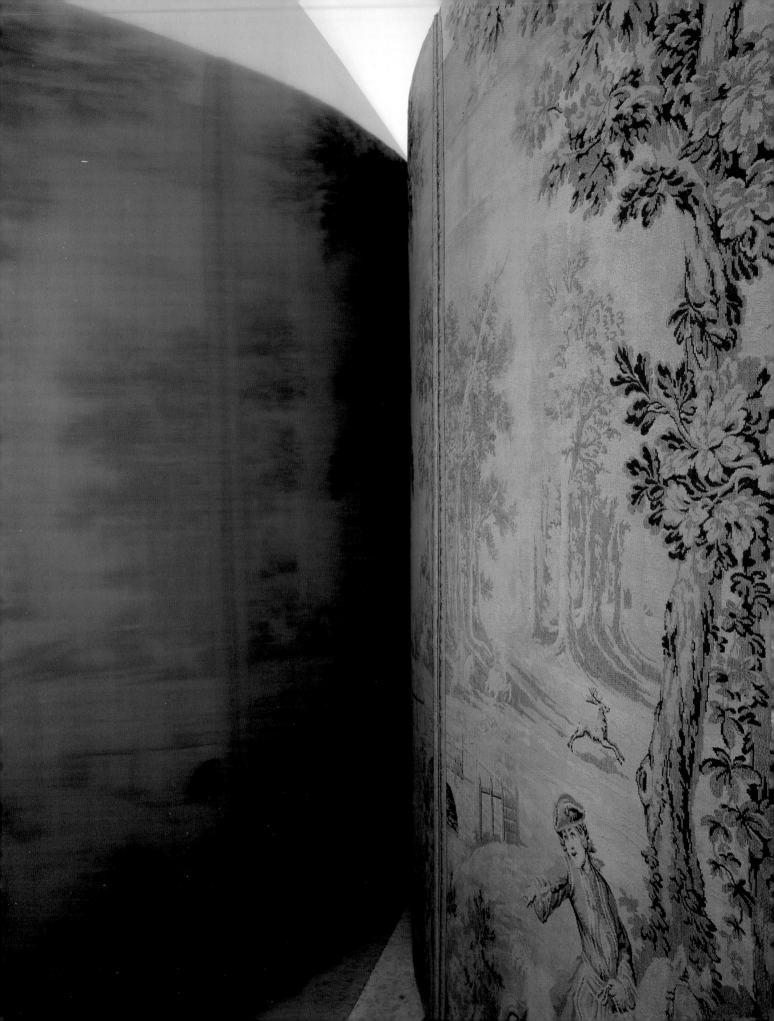

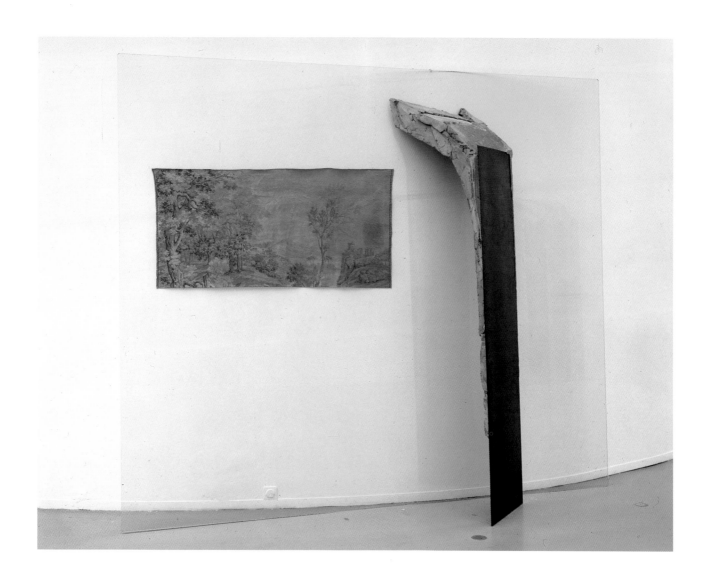

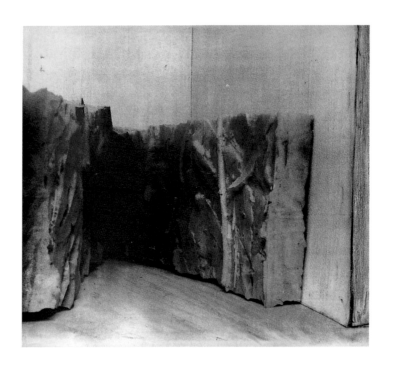

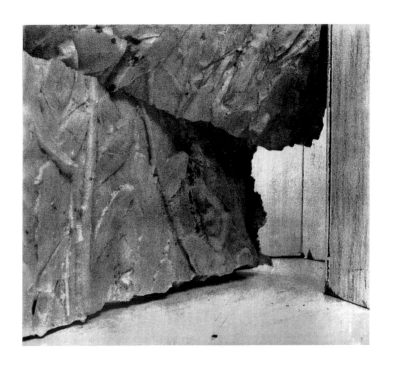

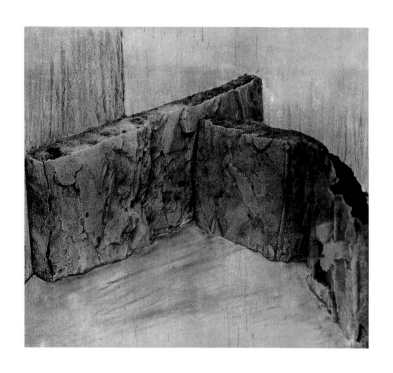

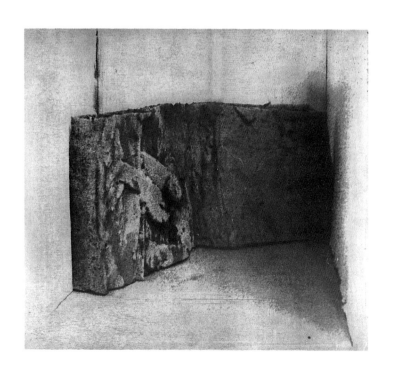

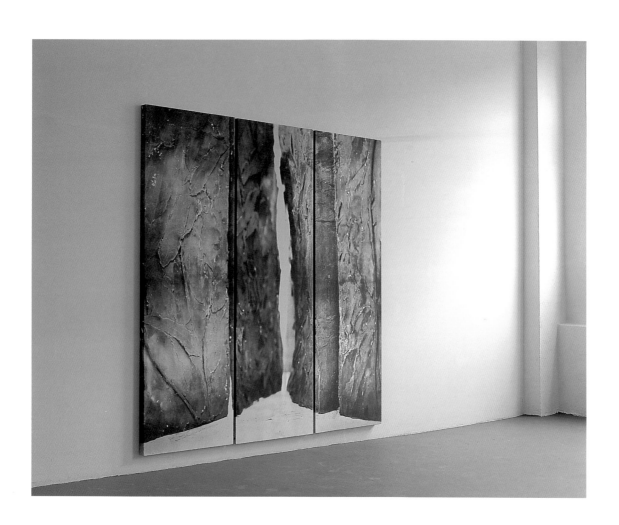

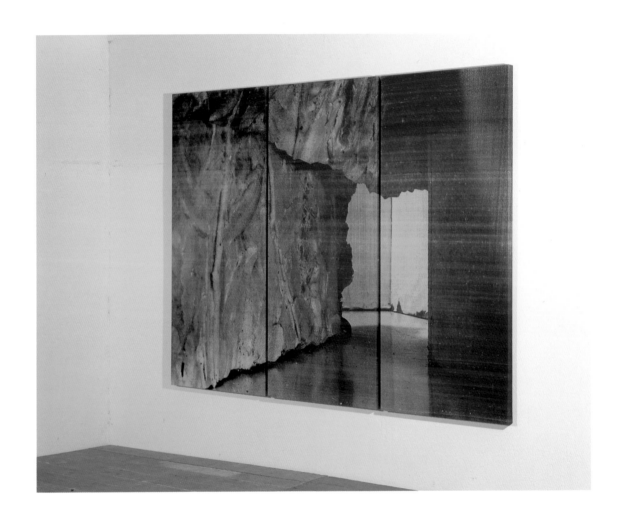

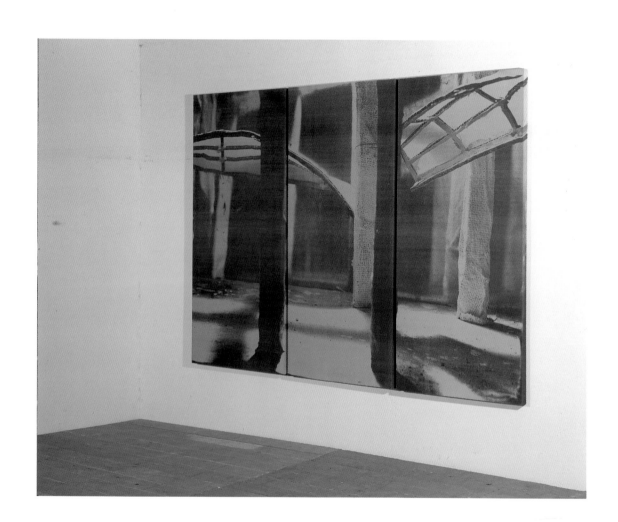

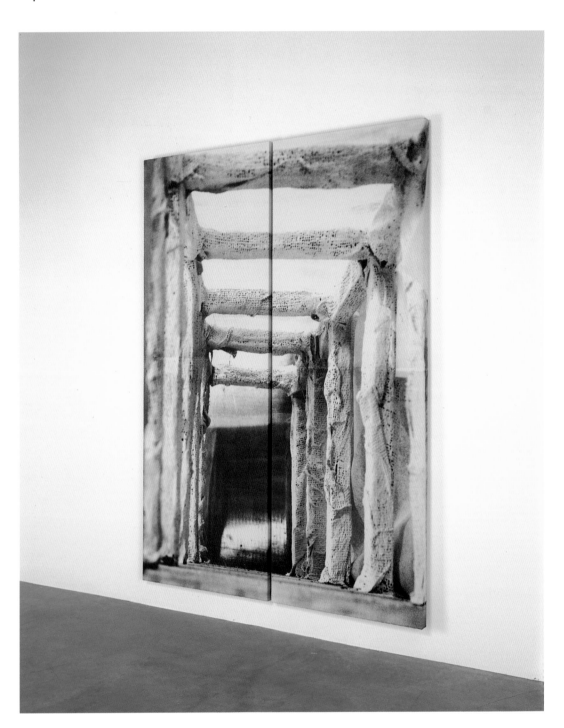

WANTING SHELTER

BARBARA MARIA STAFFORD

Is there any terrestrial paradise where, amidst the whispering of the olive leaves, people can be with whom they like and have what they like and take their ease in shadows and in coolness? Or are all men's lives like the lives of us good people ... broken, tumultuous, agonised, and unromantic lives, periods punctuated by screams, by imbecilities, by deaths, by agonies? Who the devil knows?

Ford Madox Ford, *The Good Soldier*, 1915

Why do human beings crave refuge? Of course, there is the instinct to shield the vulnerable body by discovering or creating shelters. But there is also the Rousseauean yearning for a primitive Eden: wild, remote, free. Mossy grottoes, mineral-tapestried caverns, penumbral woods, and ocean-ringed islands beguile us with Siren songs of

safety. You will be magically guarded from dangerous invasions, they whisper. Cristina Iglesias's isolating and protecting spaces are also seductive, for they evoke this escapist dream of being hedged from life. Yet the insulation from devastating passion, suffering, decay — seemingly promised by her embracing forms — is illusory. Her cement lean-tos (such as *Untitled [Venice I]*, 1993, pages 62–63), alabaster cupolas (like *Untitled [Alabaster III]*, 1993), and skeletal awnings shamble aimlessly toward an exit or define the depthlessness of a corner; some of her works (*Untitled [Hanging Tilted Ceiling]*, 1997, pages 138–39, for example) float, completely suspended, over vacancy. Even the gigantic monoliths, such as *Untitled (Bamboo Sticks I)*, 1994, pages 109–13, impressed with botanical patterns, are massive only in height. They stand precariously on a slim wedge of floor, as if to assert their ephemerality within a monitor-oriented society that has rendered all grounding extinct. Prehistoric-looking site-specific works such as *Untitled (Lofoten Islands)*, 1994, pages 98–99 — a work set atop a seaside cliff and incorporating immense natural boulders flanked by two scarred aluminum stele — similarly evoke abandonment, the falling down of ruins, the erosion of a prior ensemble.

In the digitally disembodied and delocalized cyberworld of the late twentieth century, no ideas haunt us as much as those of stable matter and fixed place. A disturbing sense of our psychic and physical homelessness surely fuels the continuing fascination with all aspects of "organic" design. The recent vogue for Charles Rennie Mackintosh is just the latest act of mourning for lost coherence. This quest for an intimate integration of rooms, furnishings, façade, with surroundings was at the heart of all modernist architectural reform. From the British Arts and Crafts movement, to the fin-de-siècle Wiener Werkstatte, up to and including the comprehensive functionalism taught at the Bauhaus from 1919 through 1933, context prevailed.

Through the agency of the Pre-Raphaelite brotherhood and William Morris, jewellike paintings, *millefiore* tapestries, and blooming carpets unfurled effortlessly into rustically timbered exteriors. Inspired by John

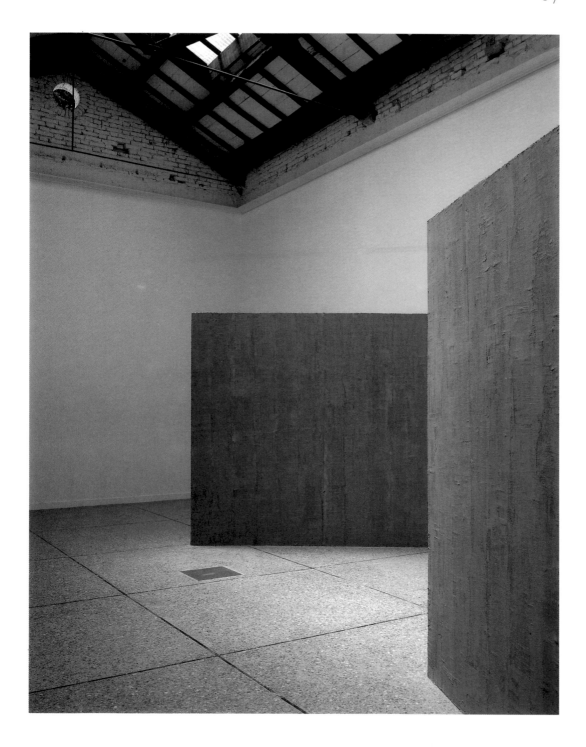

Ruskin's homages to ivy-covered medieval abbeys and the stormy sublime of Swiss mountain scenery, these advocates of the artisanal tied their designs together with tendril and cloud arabesques. By the close of the nineteenth century, the preoccupation with decorative geometries had opened a different path to spatial unification. Gustav Klimt's Minoan mosaics and Josef Hoffmann's rectilinear planes and clerestory bands thrust outward into the elegant linearism of the Art Nouveau façade. Although subsequent purist developments tended to strip architecture of such richly figurative allusiveness, Mies van der Rohe's airy skyscraper grids and Alvar Aalto's penchant for harmonizing steel with wood were equally based in a collectivizing impulse.

Whether extolling or decrying ornament, these very different kinds of modernists nonetheless relied on the firm armature of a given setting in which, or against which, they located their projects. Frank Lloyd Wright's procedure of gathering rocks from the gullies and sand from the washes, used in erecting the low, battered walls of his architecture school at Taliesin West, 1937–59, remains the quintessential expression of this holistic desire to bind. Navajo-inspired ramadas form a sophisticated camp, cradled within the Sonoran desert at the foot of Scottsdale's McDowell range.

In rebellion, the deconstructive drives of postmodernism have not only wrenched residence from real estate — as in Frank Gehry's casually heaped, playful aggregates strewn about Santa Monica — but ripped supports from their bases. Arakawa and Madeline Gins's *Critical Resemblances House, Site of Reversible Destiny—Yoro*, 1993–95, located in Yoro Park near Osaka, mirrors, dissects, and resutures equipment typically found in an ordinary home. Pieces of furniture, appliances, and plumbing — normally bolted down — are clamped to the ceiling or swim underfoot, eerily visible beneath the glass pavement.

Similarly, Iglesias's anatomized elements, while retaining a strong hieratic presence, show just how uneasy earlier, assured meldings of site with structure have become. Analogous to Richard Long's neolithic-appearing

stone circles or Kim Yasuda's egg-shaped marble boulder (1991) — incongruously planted adjacent to Tokyo's gleaming International Forum — Iglesias plays up dissonance and subverts the surrounding streamlined public area. All claims to an intrinsic connectedness between pristine exhibition space and chiaroscuro assemblage are gone.

Unnervingly, she confronts us with a section of a dim corridor (*Untitled*, 1993–97, page 73), a glazed portion of an overhang (*Untitled*, 1993, pages 56–57), an arc of an exposed buttress next to a remnant of tapestry (*Untitled*, 1987, page 75). Each construction is partial, provisional, or broken. And whatever thickness swells these material objects, their density quickly dissolves within the rarefied atmosphere of the immaculate art gallery. Much like Catherine Wagner's *Sequential Molecules*, 1995, nine gelatin-silver prints of glass vessels used in organic-chemistry experiments, residue merely serves to highlight thinness. In Wagner's photographic grouping, the ghostly precipitated crystals accentuate the fragility of the glowing containers and the chill emptiness of the laboratory. Iglesias's wide-apertured, pared-down artifacts similarly demand severe viewing conditions. But the banishment of any overarching totality and the attenuatingly neutral setting specifically address today's urban realist. Refuge has become intermittent, offering a brief respite from intrusive transparency and a momentary lull in multimedia exposure.

The absence of any larger interlocking context serves to emphasize the totemic solitude of Iglesias's secular shrines to privacy. In works such as the series *Untitled (Bamboo Forest)*, 1995, pages 115–19, the visitor walks alone into a quiet sanctuary; in others, he or she stands contemplatively under cast reflections. The history of art is riddled with such secretive enclosures, now dilapidated. Recall the narrow corridors in Egyptian Old Kingdom tombs, the tight corners of Mycenaean passage graves, the glimmering apses of Gothic cathedrals, the crenellated ramparts of feudal castles, and the labyrinthine garden grottoes of Twickenham and Stourhead. Nowhere, however, does one get a better sense of the sheltering potential of lithic

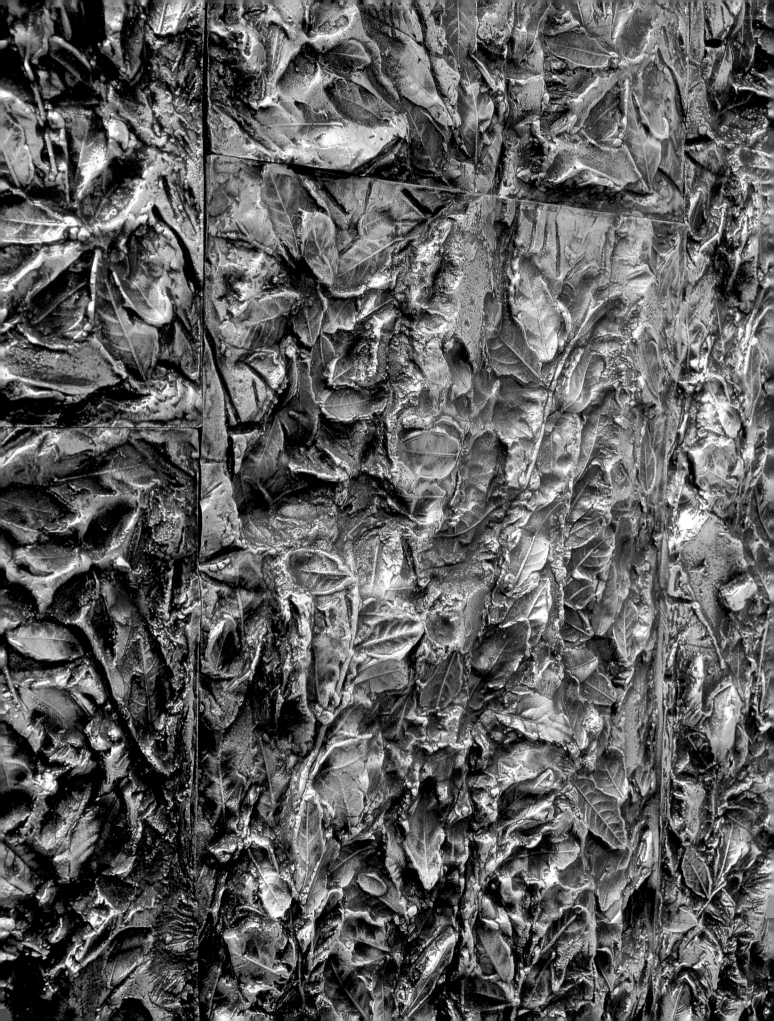

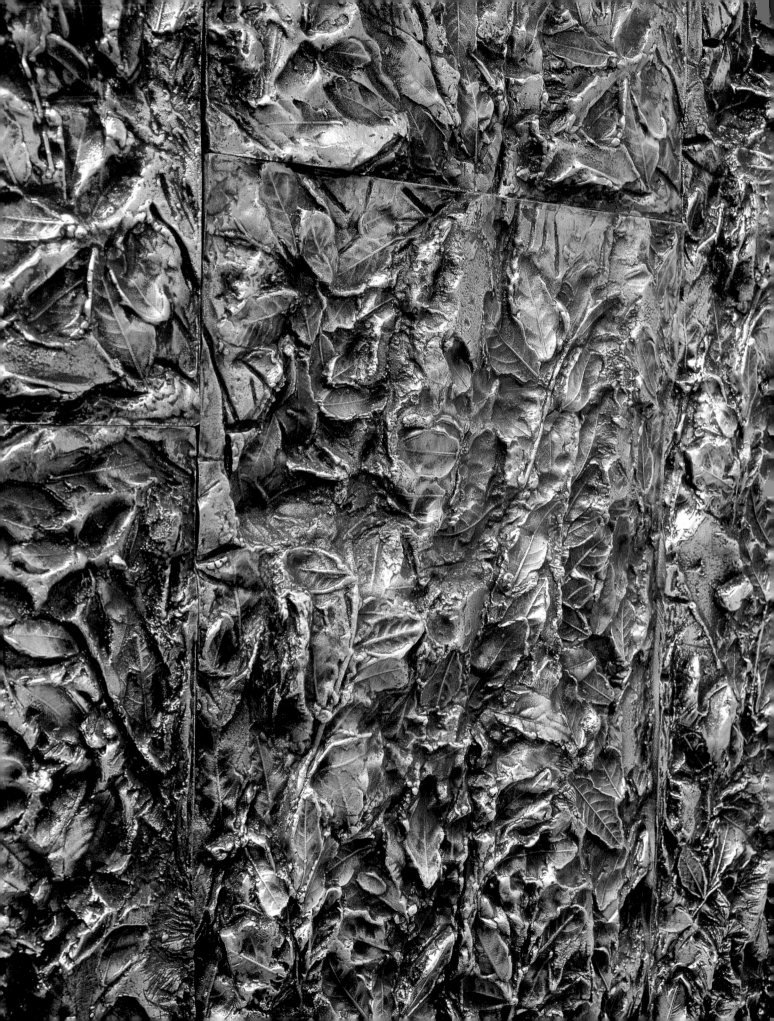

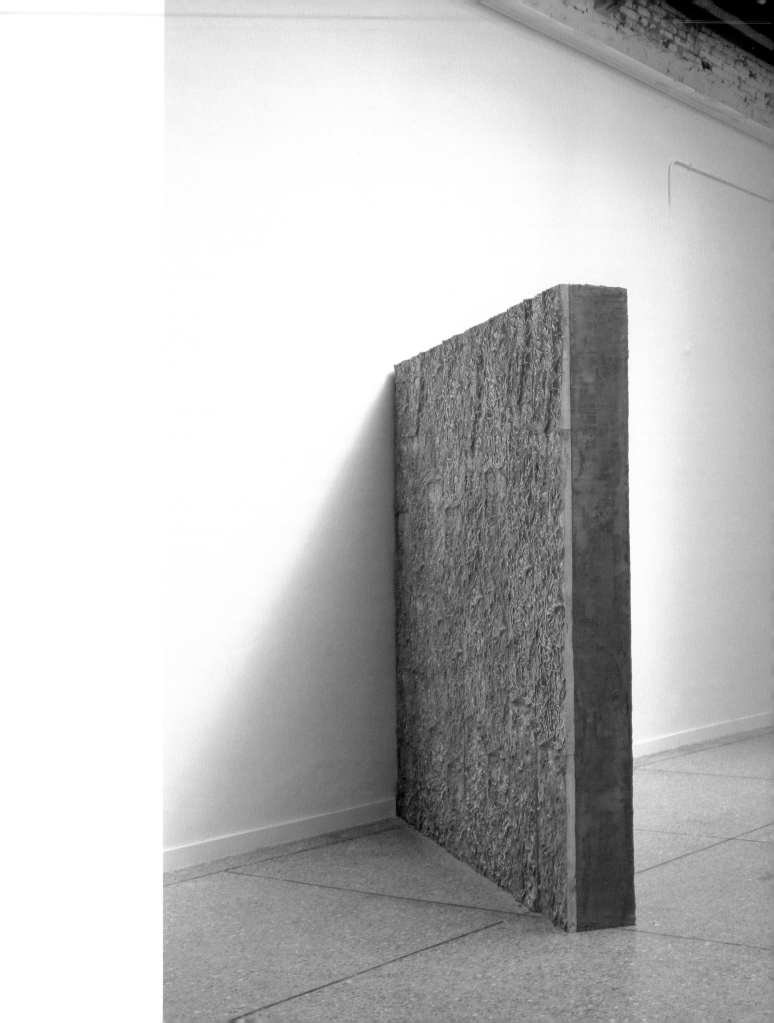

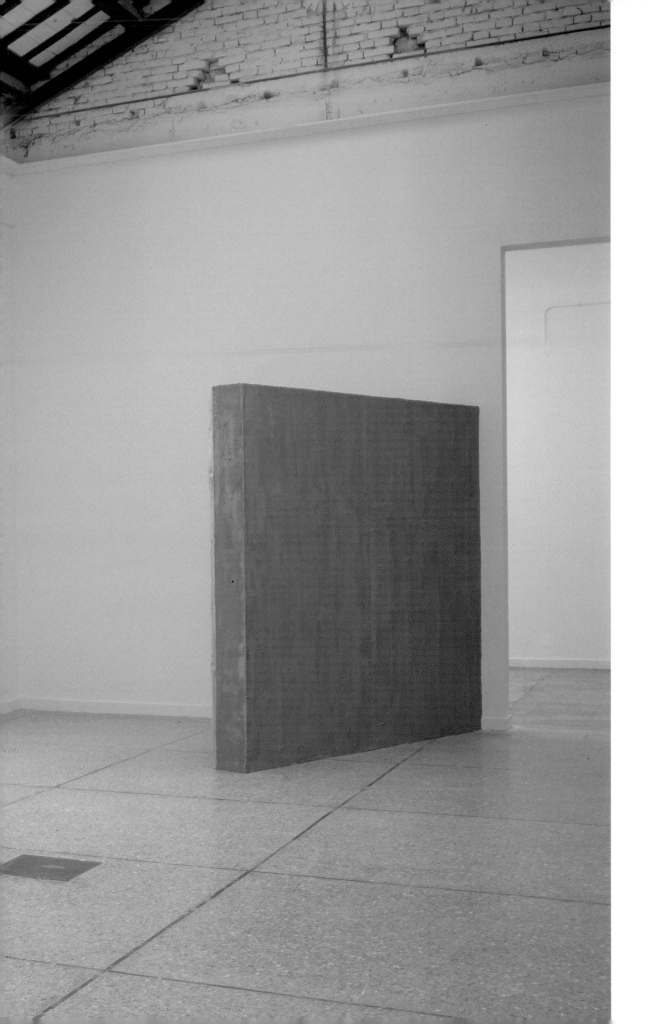

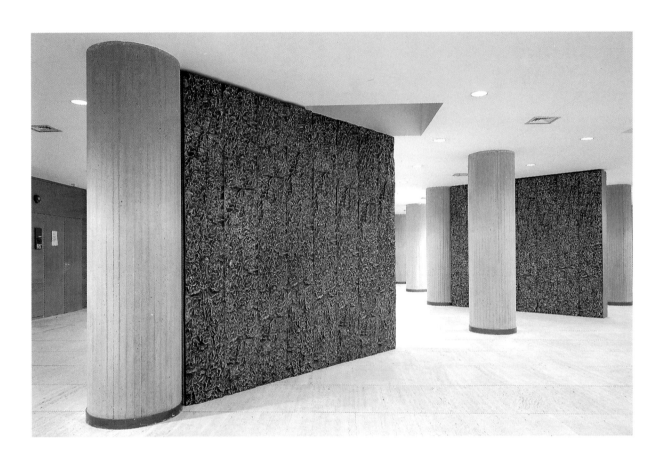

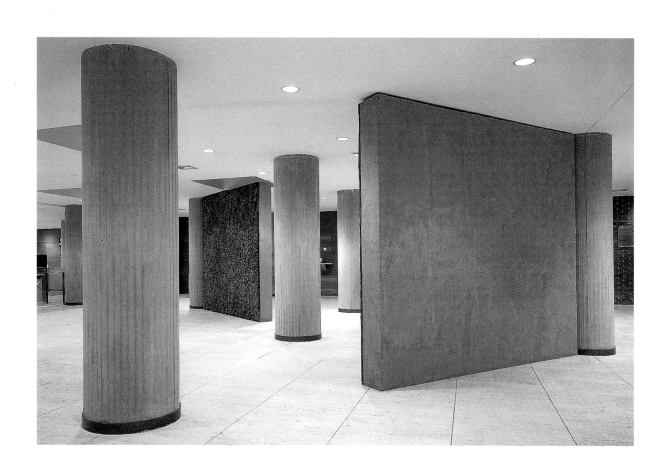

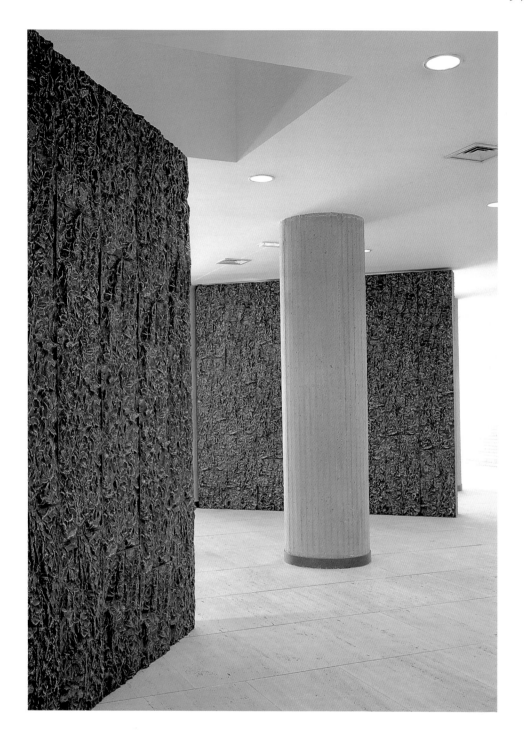

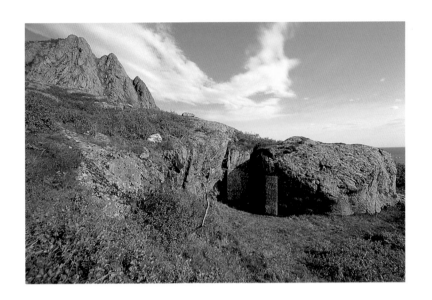

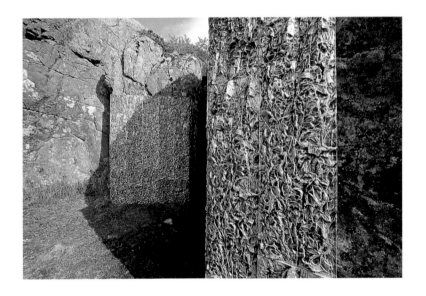

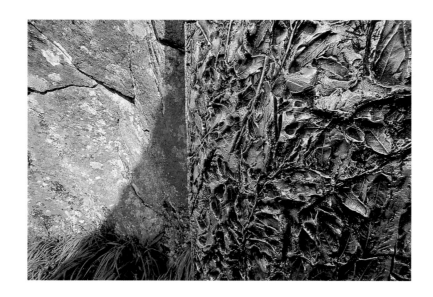

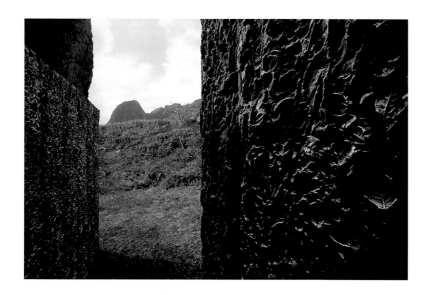

fragments than in the American Southwest. That vast desert "museum" — stretching from Arizona's Saguaro National Monument to the chromatic canyons of Utah and the Dakotas to the lunar topography of the Rio Grande gorge — is punctuated by spare half-artificial, half-natural formations rising or sinking into blankness. These Cubist angularities hover illusionistically somewhere between a built and an unbuilt habitat. Vertical lines and catenary curves, visible from all 360 degrees of the encircling panorama, scarcely dent the immensity of the sky.

The long, steep climb up the Colorado Plateau from Sedona to Flagstaff and on to the mysterious Mesa Verde cliff dwellings is marked by straight, and insistently mural, uprights of ambiguous composition and confusing origin. "Montezuma's Castle," Red Rock, and Walnut Canyon set a seal on our imagination forever. Once beheld, those simultaneously desolate and comforting landscape features become a standard against which all future environments concerned with concealment or exposure must be measured.

They owe their impact, first of all, to sheer physical relief. Overhanging crags, narrow shelves, and fissures magnified by the wind into galleries offer temporary respite from the summer's hideous shadelessness, from the glare and dust generated by the endless, mirroring flats ebbing and subsiding around Phoenix. This initial sensation of a hellish blaze is rapidly succeeded by a surge of respect for looming and motionless masses capable of enduring such ruthless shining. Much like the inescapably bright emptiness of the museum interiors in which Iglesias's concrete and colored-glass passageways, bamboo or eucalyptus glyphed aluminum blocks, and eroded arches stand or lean, the brilliant vacancy of the Painted Desert also favors the cryptic minimalist fragment. In either case, valiant remains convey the mixed impression of being survivors and victims, refuges and refugees.

Atemporality — the quality of belonging to no time, or deep time, or all time — characterizes both the lone butte and the still uncrystallized, ecological projects dating from the 1960s dotting Arizona's arid wastes. Paolo Soleri's slowly evolving *Arcology* — a bizarrely variegated collage of science-

fiction pods — springs from the cactus-littered floor of an ironically named Paradise Valley. The utopian vision, kept alive by his Cosanti Foundation, called for the development of a prototype for multiple-use habitats made integral with harsh environments. The desiccated prehistoric ocean bed provided the perfect analogue to current city blight. At completion, it was thought that six thousand people might live in compact complexes with large-scale solar greenhouses on twenty-five acres of a four-thousand-acre preserve. In actuality: tunnels gape, the amphitheater is unfinished, silt-covered vaults are partially painted, and apartments need walls. Dramatically surging from the basalt slopes near Phoenix's Cordes Junction, the heroic stubs of this citadel for world peace are moving reminders of human aspiration run aground. Like Charles Simonds's soil-hugging terra-cottas of prehistoric civilizations — earthworks originating during the same idealistic era — Soleri's weathered buildings simultaneously cling and crumble to earth.

But what of an older communal life in America, one combining the dramatic silhouette of the mesa with the abstraction of indigenous design? I am thinking of those ancient habitations hanging in midair and hewn into the center of unscalable cliffs. What kind of fear or terror makes people sculpt fortresses alongside the swallows in the middle of zooming slickrock? The Sinagua Indians, who flourished around A.D. 1000 and mysteriously disappeared some four hundred years later, left behind a precisionist architecture of rosy plastered adobe, carefully sliced open here and there to reveal tiny windows and minuscule doors. Ansel Adams, photographing by moonlight at Canyon de Chelly, hauntingly captured how these elemental solids and voids were wedded to the sandstone against which they backed. Starvation (from drought and teeth worn to the jawbone) or, perhaps, warfare eradicated maize-eating cultures like the Sinagua and Anasazi. No one knows why or when for certain.

From Tuzigoot (signifying "crooked water" in Apache) onward to the mountaintops around the darkly green Verde Valley, the traveler increasingly

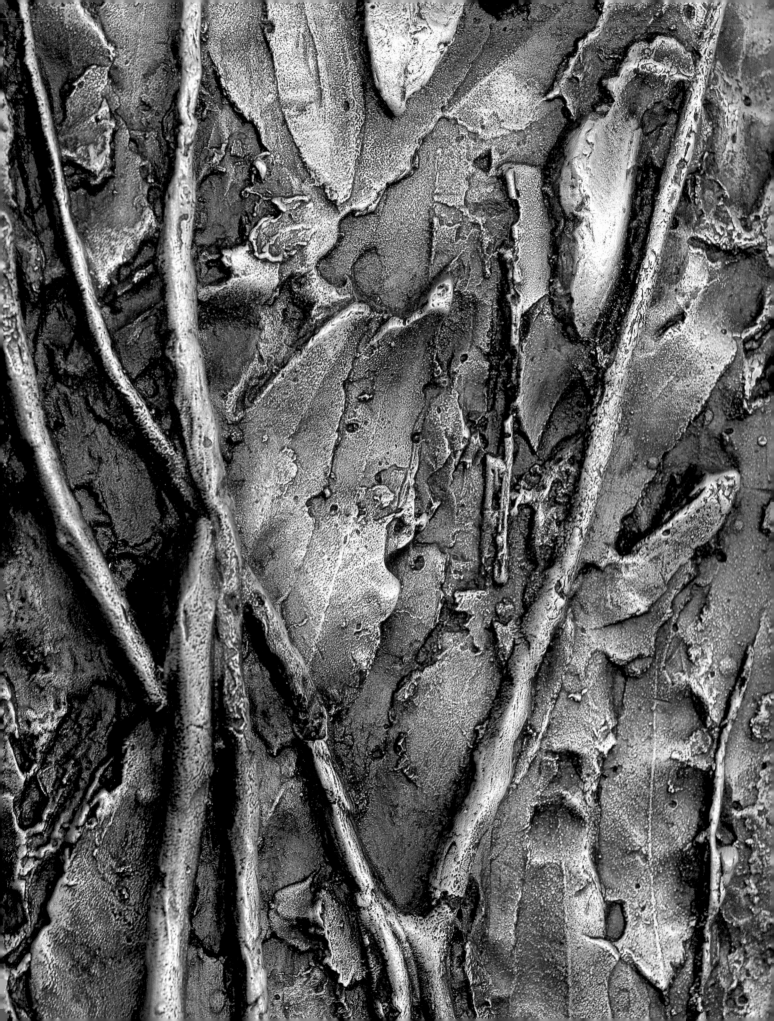

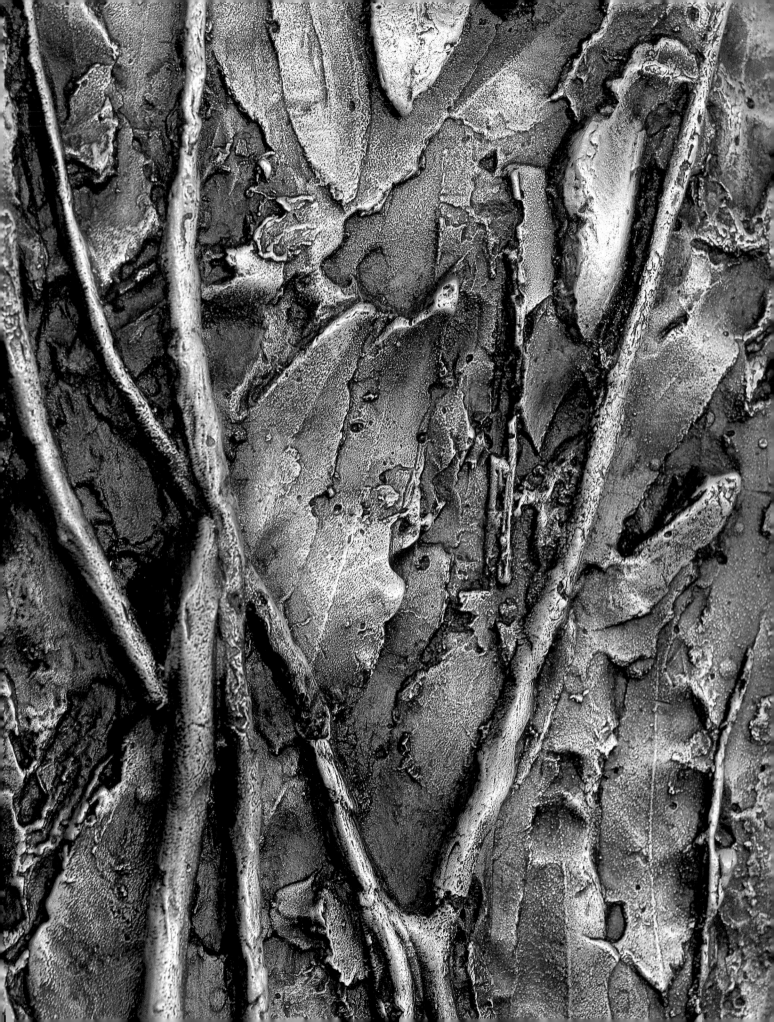

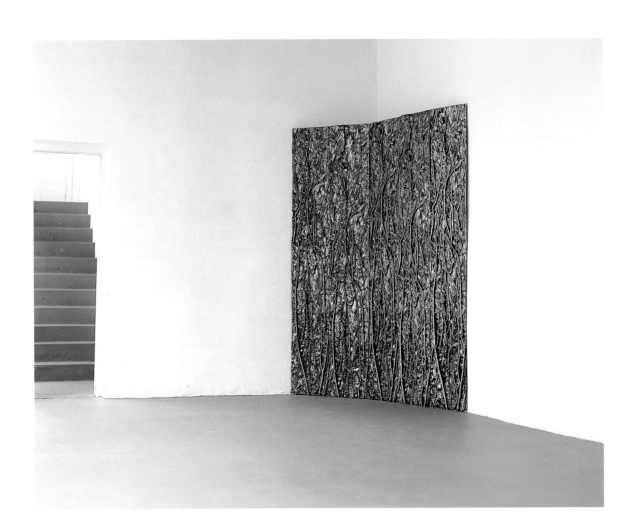

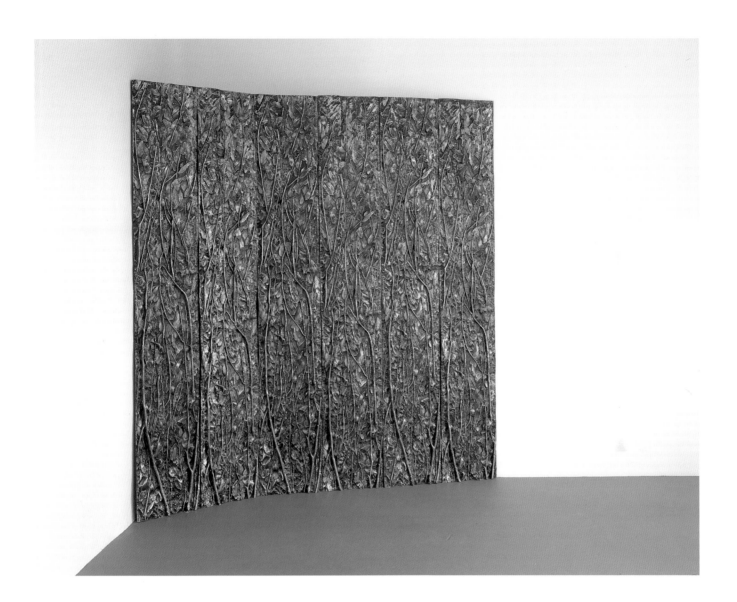

glimpses the disintegrating geometries of suspended pueblos resembling nothing so much as flattened and purified natural features. These hermetic structures are mute except for the raucous cry of crows and the creak of ponderosa pines snapping in the dry air. We cannot fathom the original inhabitants' joys and sorrows from the impassive and inscrutable physiognomy of the mouldering façades. Climbing ladders to prowl the mud floors of the upper stories or worming one's way through narrow, windowless passages offers no enlightenment about actual use and function.

Exploring a succession of enigmatic "Cliff Palaces" or "Balcony Ruins" — actually artificial caves bored into the smooth faces of curved canyons — makes plain how radically the concept of refuge has altered from premodern to postmodern times. Feminine *kivas* (rounded pithouses), masculine square towers (set securely into the live rock), and cosmic *sipapus* (holes dug into the middle of settlement sweat houses so that the spirits of the upper and lower regions might mingle), were rooted in the dirt. Mary Elizabeth Jane Colter, chief architect for the Fred Harvey–owned Santa Fe Railroad hotels, played up this paradigmatically organic aspect of Amerindian construction. Witness the massive, adobe-like rough plaster walls of her Hopi House, 1905, the haphazardly jumbled boulders of Hermit's Rest, 1914, and the romantically ruined Watchtower, 1932, all still to be found at Grand Canyon. Certainly, these vanished tribes suffered mounting hardships-consistent with climatic change, poor hunting, and disease. Yet she, too, sensed a profound assurance reflected in their dwellings that derived from building on solid rock. Living may have been hand-to-mouth, but it was durable matter against which the ancient Anasazi pitched, extended, raised, or supported their beam-latticed roofs.

The warmth and stability of the red earth is absent from the icy whiteness, paper walls, and fretful transformability typical of current exhibition sites. Intrinsically mutable and manipulatable, these decomposable spaces for shifting displays are emblematic of the restlessness governing our phantomized electronic existence. It is the strength of Iglesias's beautifully

crafted constructions to make us aware of just how erratic, temporary, and brittle the notion of shelter has become. When walking into her provisional enclosures, the viewer is struck by their deliberately hesitant and awkward relation to a museum's movable partitions, sloping ramps, or uninhabitable scale. These vestiges always give the impression of having been somehow skewered, displaced, or self-consciously out of place. Constricting arcades head nowhere, preferring to huddle in corners. Then there is the arbitrariness of stationing grand, organically embossed metal slabs in the center of an empty exhibition space. Since these artificial formations (such as *Untitled [Eucalyptus Leaves II, III, IV]*, 1994–96) frame emptiness, they function as if they were the sides of a collapsible tent.

Cantilevered brackets, sensuously glazed with a diaphanous skin of color laid over metal struts, define an otherwise unremarkable patch of flooring. How different from Antoni Gaudí's delightfully spidery, wrought iron entrance gate for the apartment block, Casa Milà, 1905–10. The intense Barcelona sun, piercing the openings, assertively checkers the threshold imparting the dignity of liminality to what is, after all, merely transitional space. More akin to the tentativeness of Jim Hodges's silvery web, *In Blue*, 1996, Iglesias's lacy drapes of faintly shadowed light fleetingly make something out of the anonymous nothing stretching below or behind them. In comparison to the filmy delicacy of Iglesias's translucent installation such as *Untitled (Alabaster Room)*, 1993, pages 46–53, Daniel Buren's granite stripes or Sol LeWitt's broad-band slanted wall drawings look heavy and coated. Neither a hard-edged minimalist nor a conceptualist, then, Iglesias is a fabulist enacting cautionary tales about the rupture of embodied past from disembodied present. Her marring of rigid geometries and pristine grids emphasizes the worn, the effaced, the sundered.

This foregrounding of vulnerability is so unsettling precisely because the archaic forms she invokes and reconsiders conjure up myths of divinely guarded and guarding structures: Cretan maze, Hindu cavern, Irish barrow, Brittany dolmen, French Gothic buttress, and New World ledge. But

neither the physical nor the psychological conditions that once made such secluded habitats feel reclusive prevail today. The lucid volumes and carefully contrived openings of legendary architecture have turned perplexing and random in Iglesias's projects. The baffling effect of porous shelters that do not shield well or for long puts an intolerable pressure on the meaning of mental security. We are tempted to enter her glowing hollows, not to flee battle or sickness, but to evade some greater, nebulous and nameless, anguish that is hard to pin down. Unlike a charmed amulet or enchanted talisman these intense, yet imperfect, refuges merely ward off peril for a moment. Yet in alluding, however paradoxically, to serene and coherent systems of ordering, they permit us to experience a tentative safety. Both the despair and the consolation of postmodernist protective layerings, she seems to suggest, is that they are all surface. There is no absolute or permanent substructure shoring up human productions. Whatever haven is given to us lies within the manifest structure, not behind, but before, the eyes.

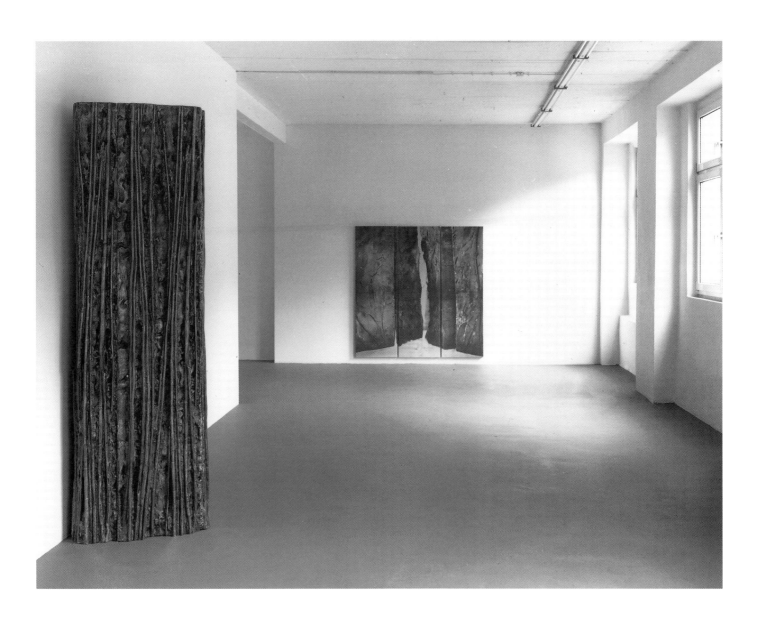

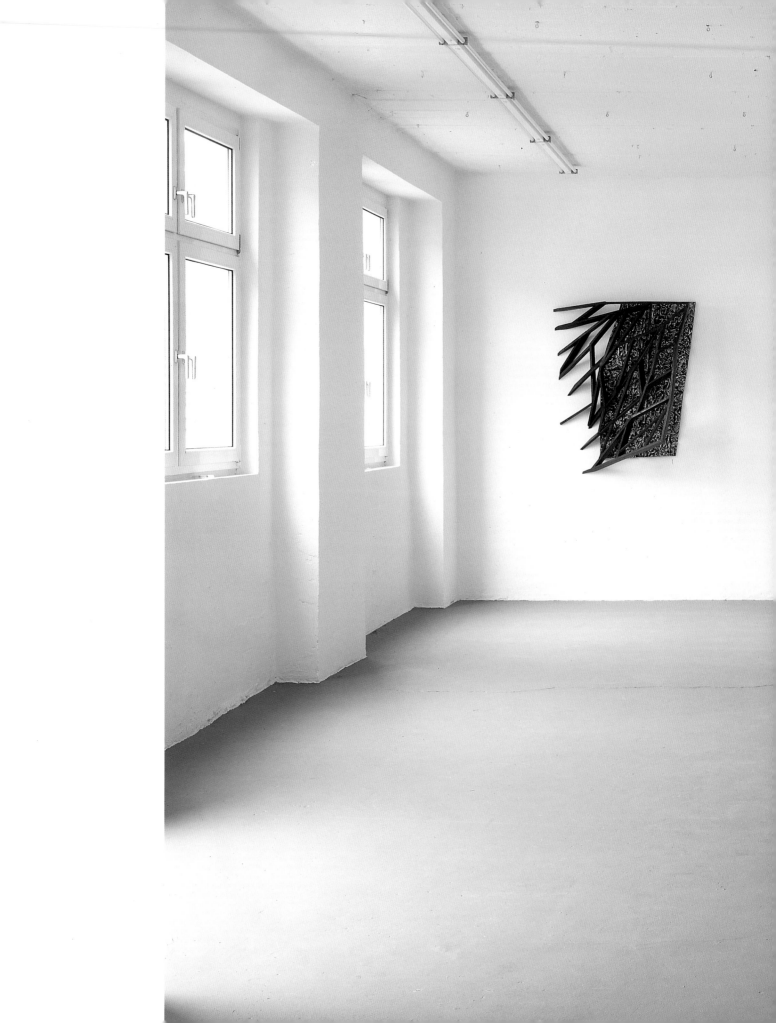

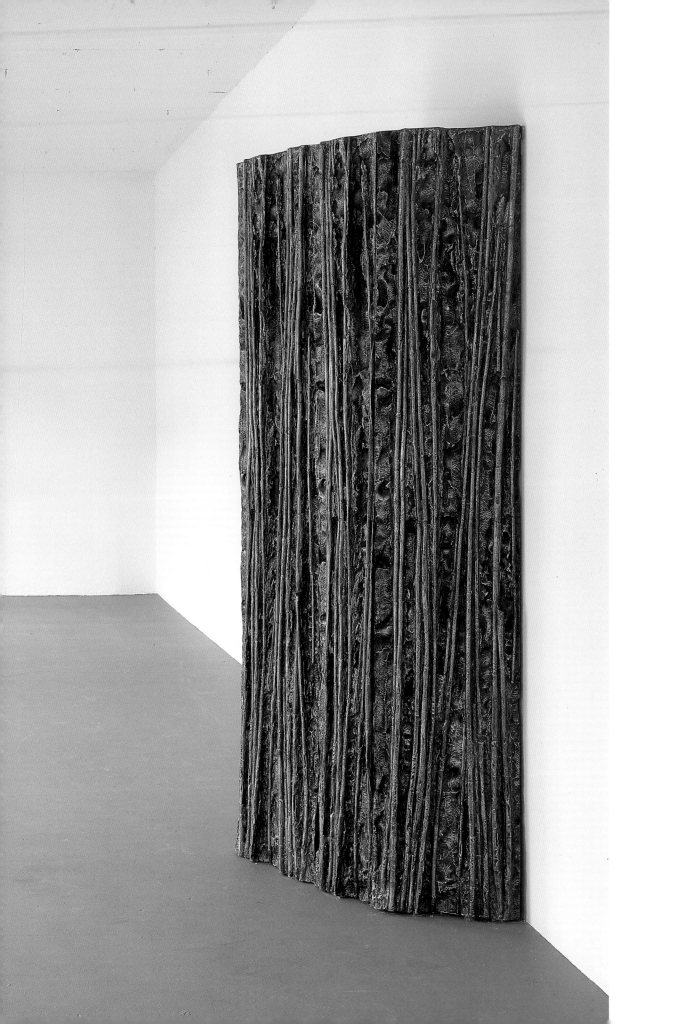

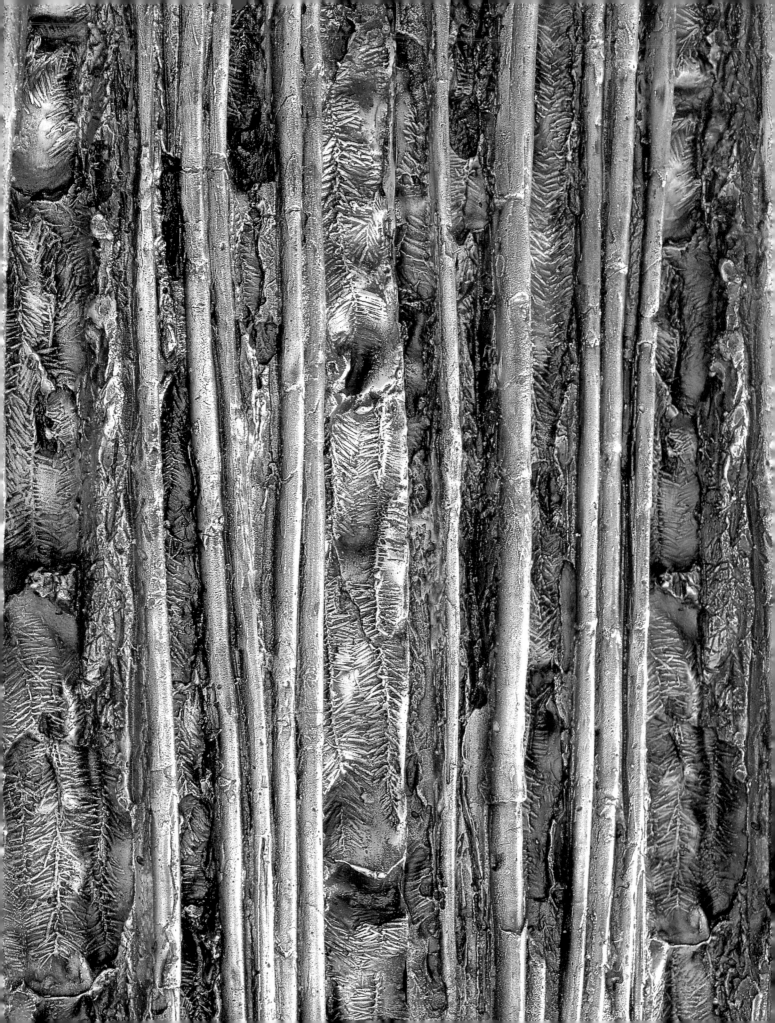

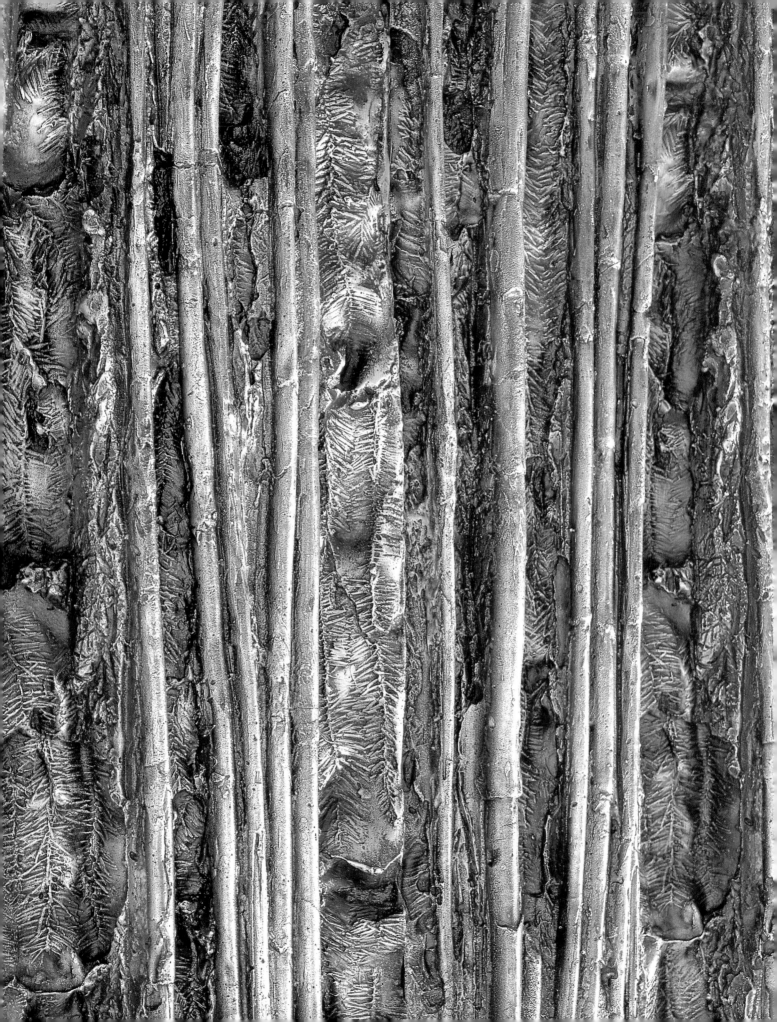

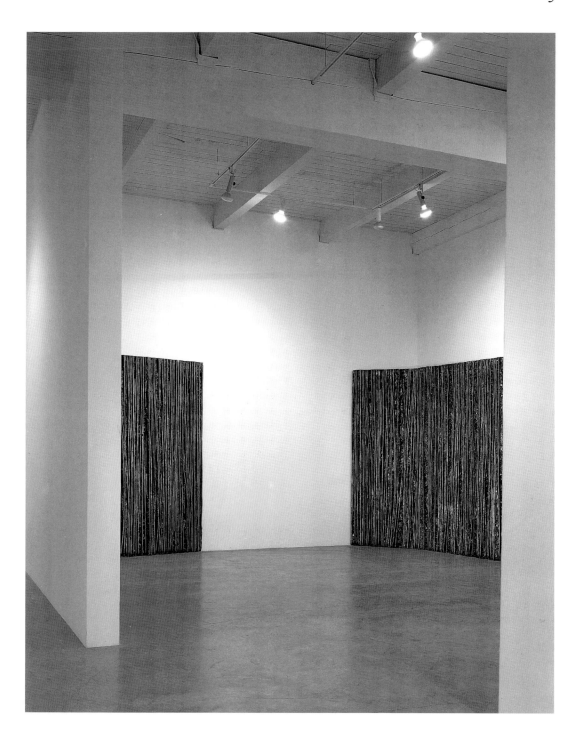

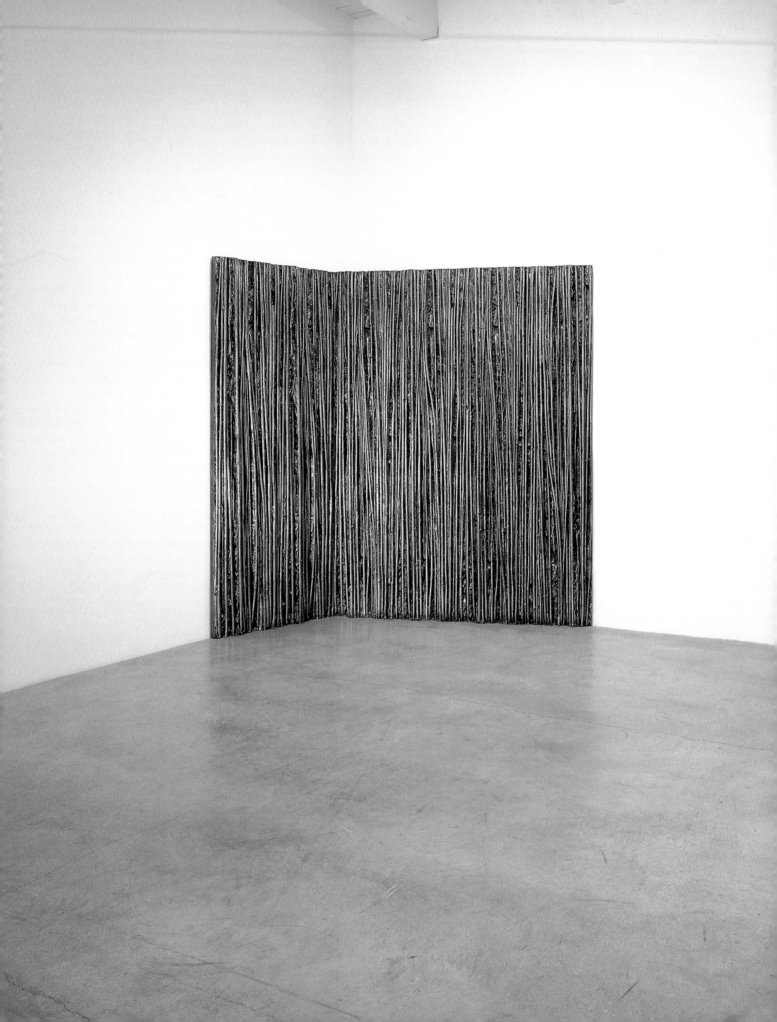

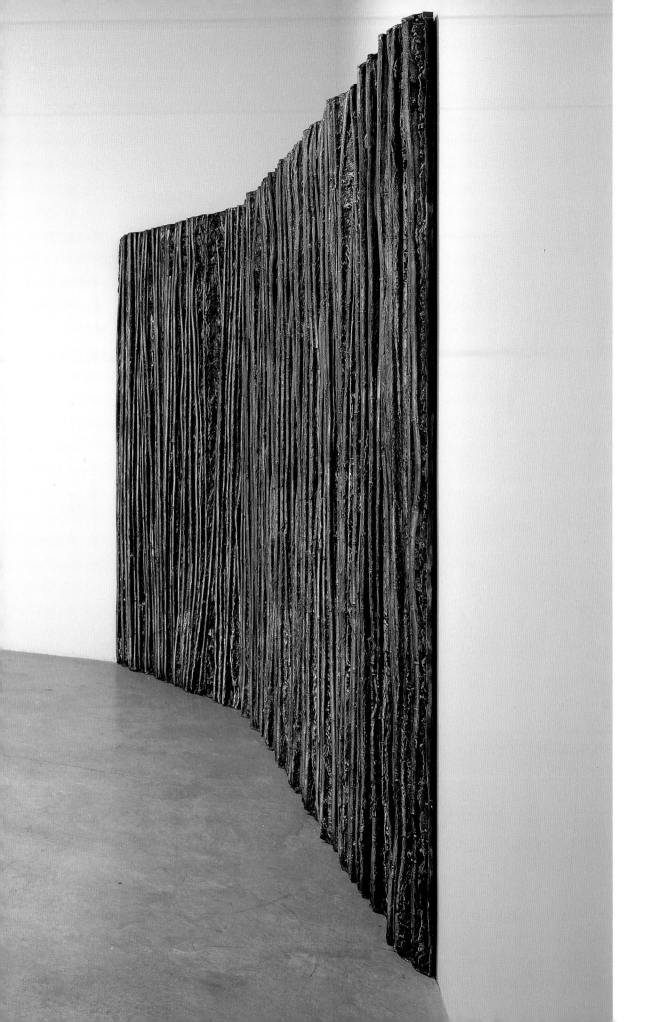

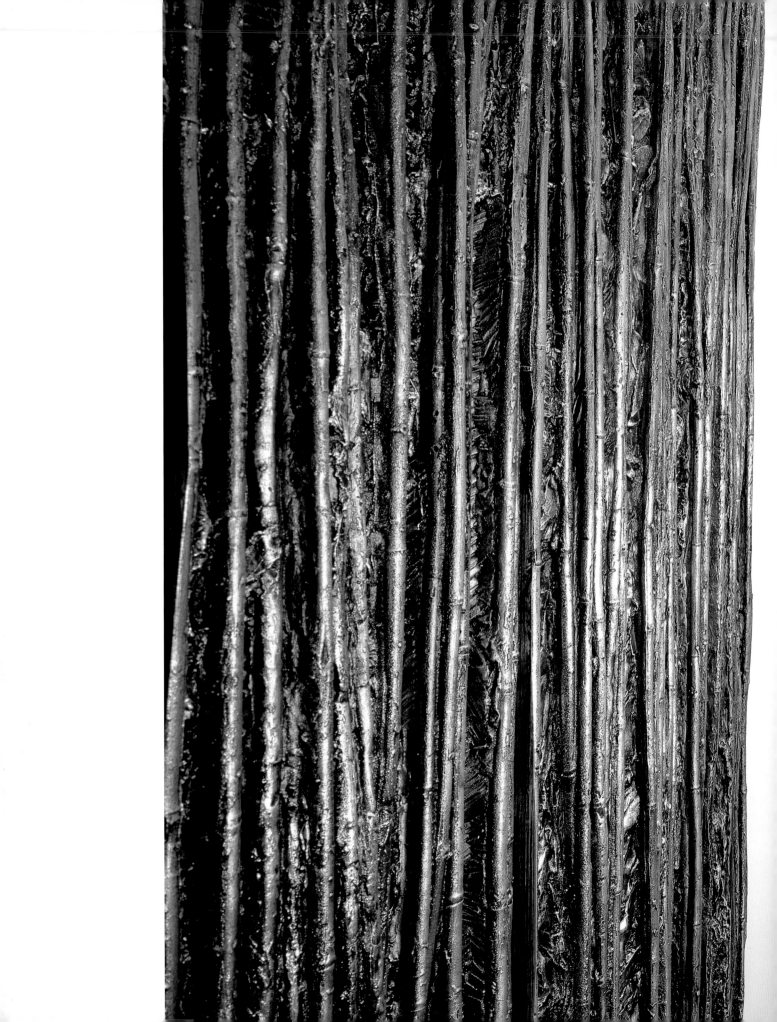

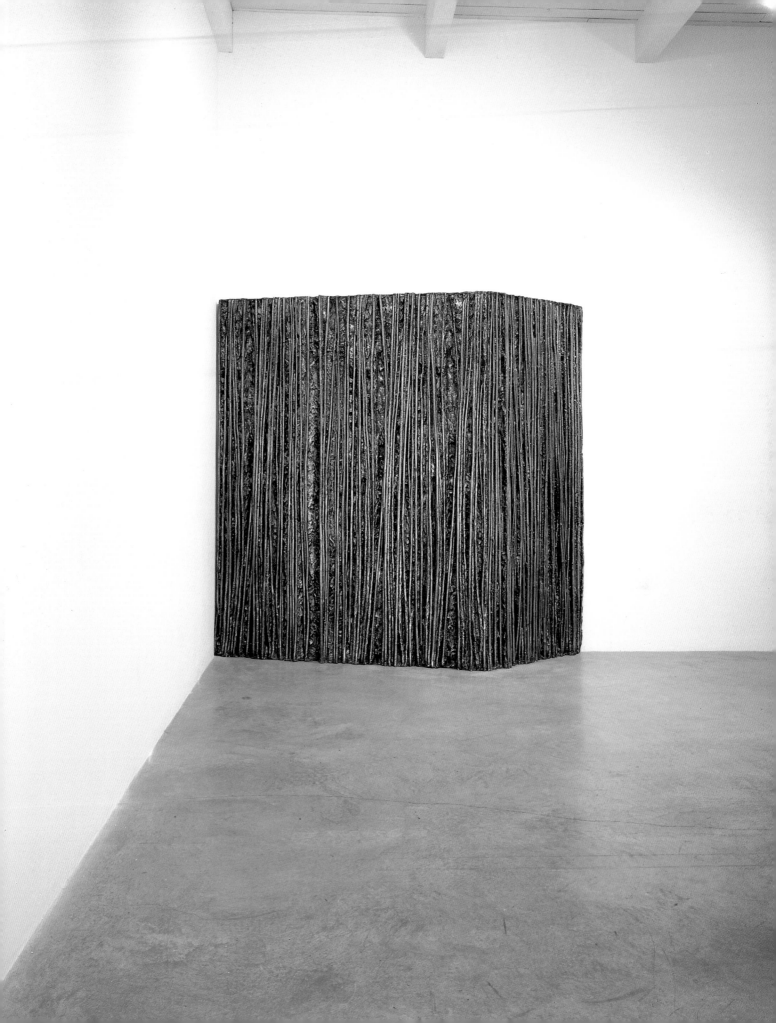

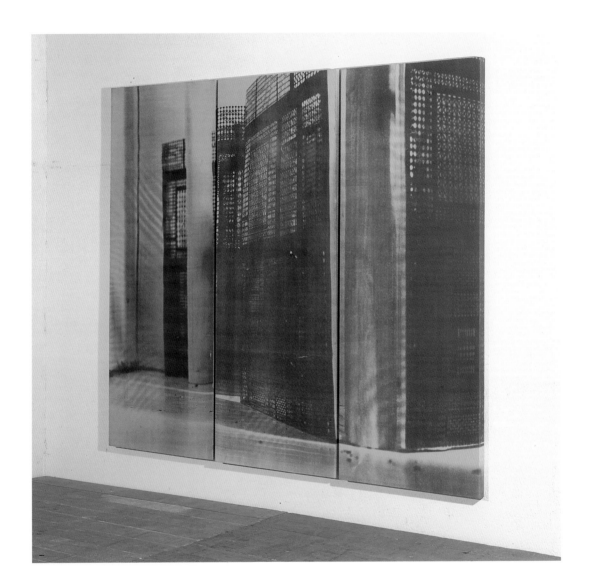

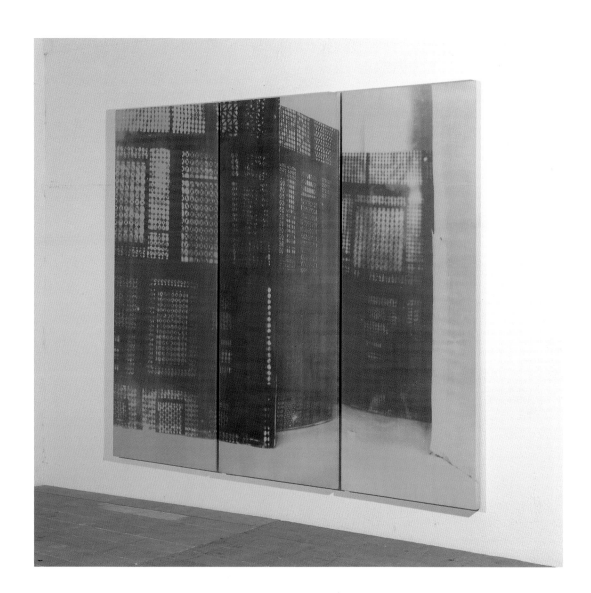

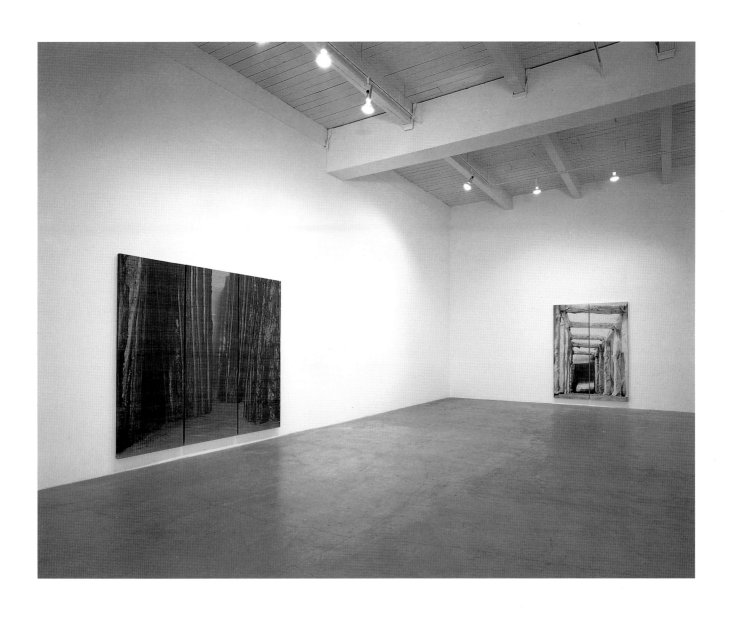

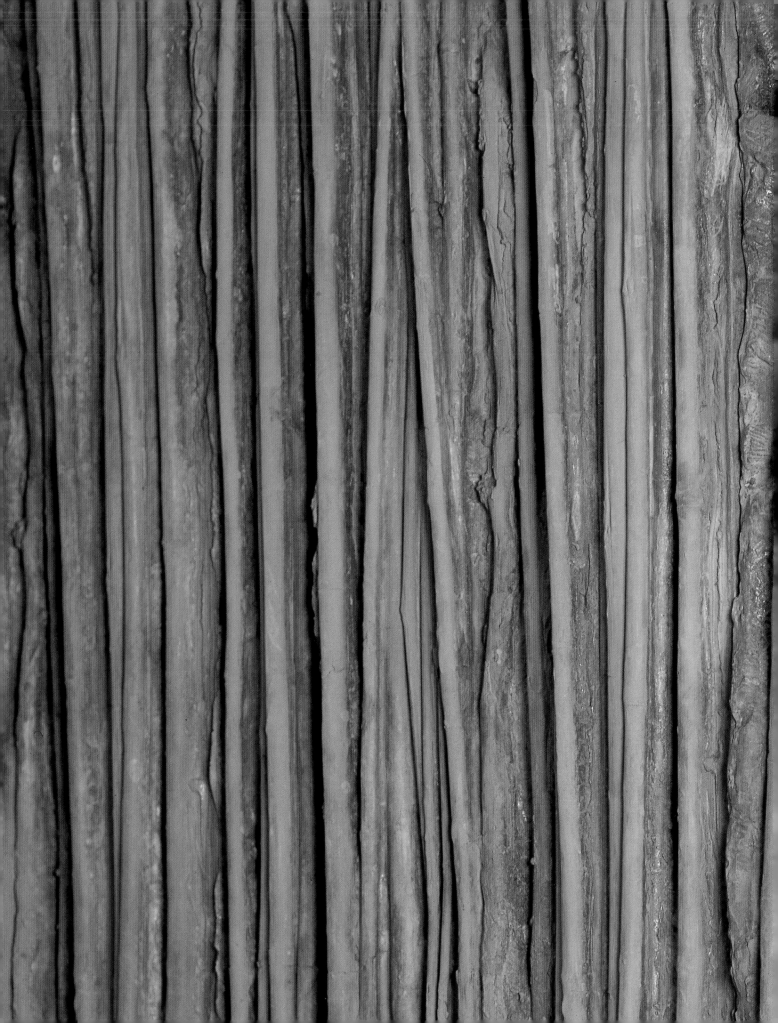

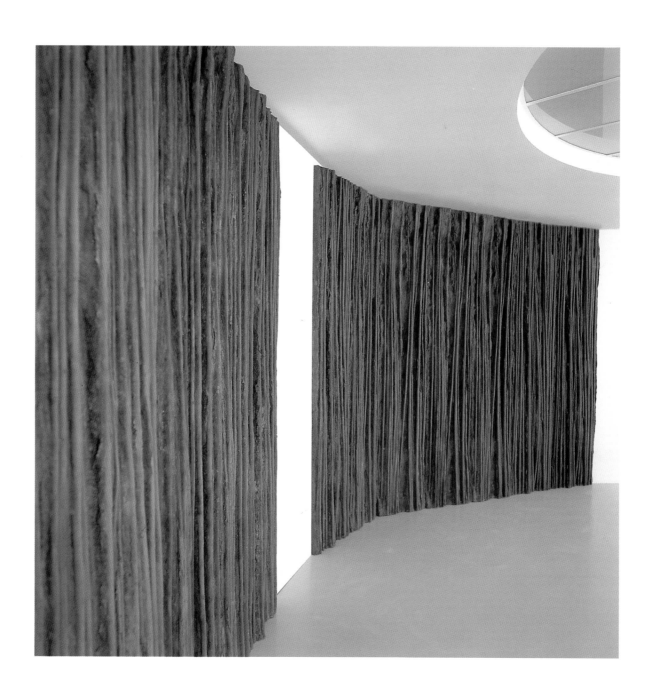

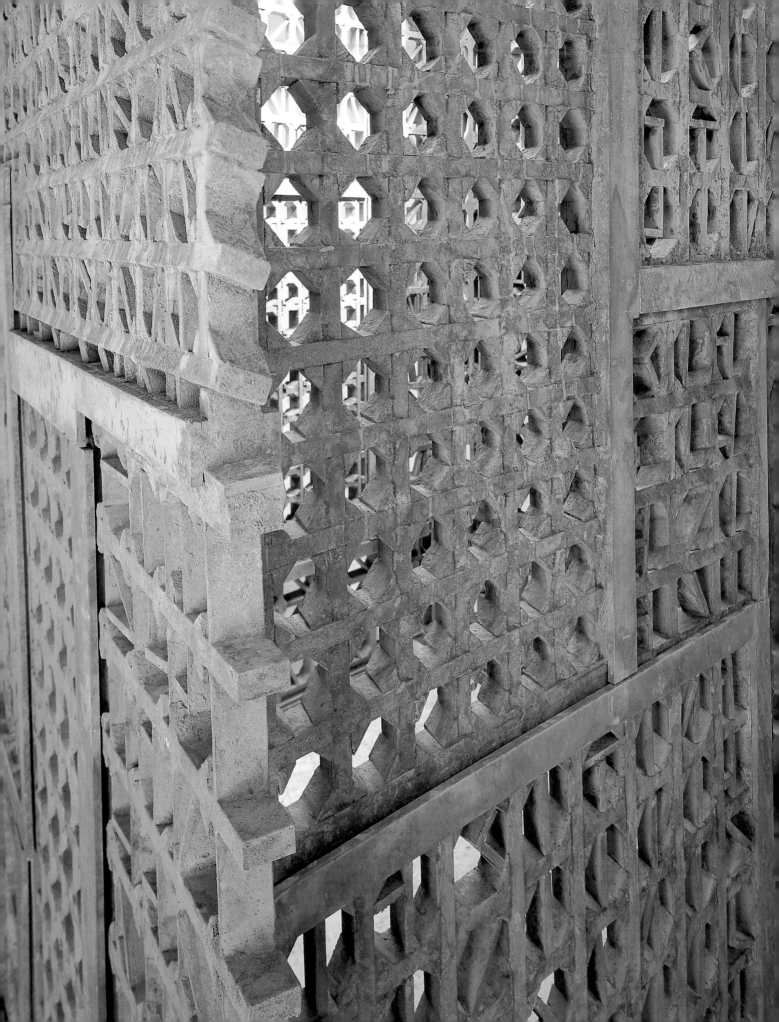

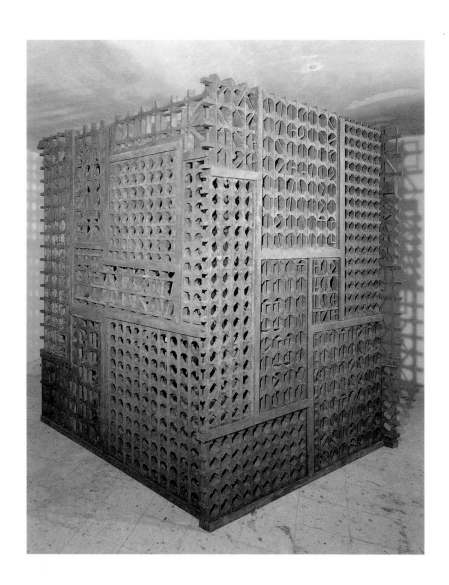

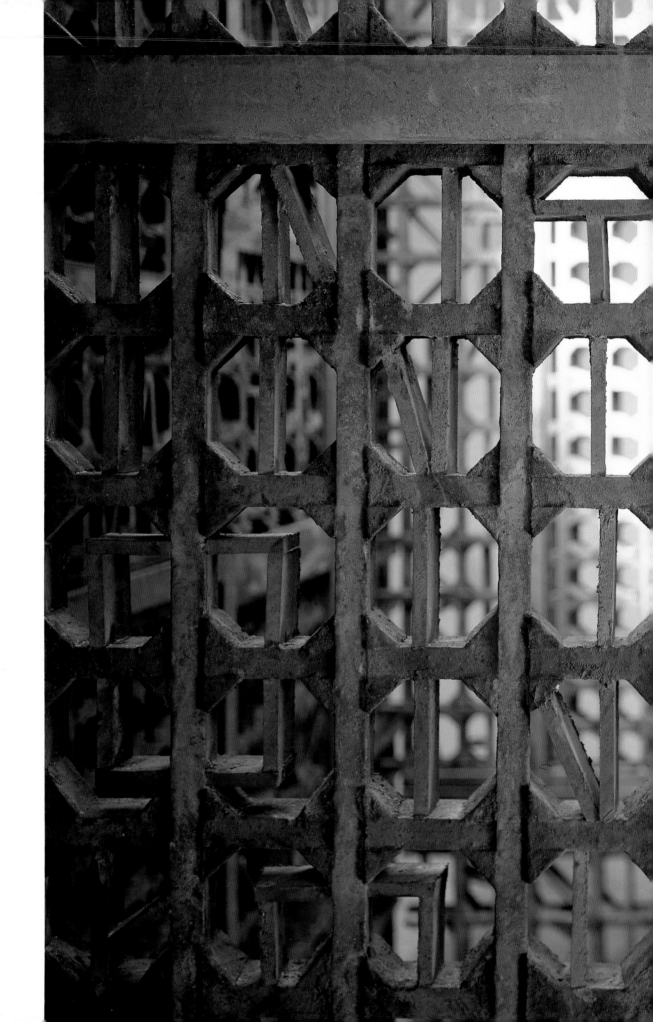

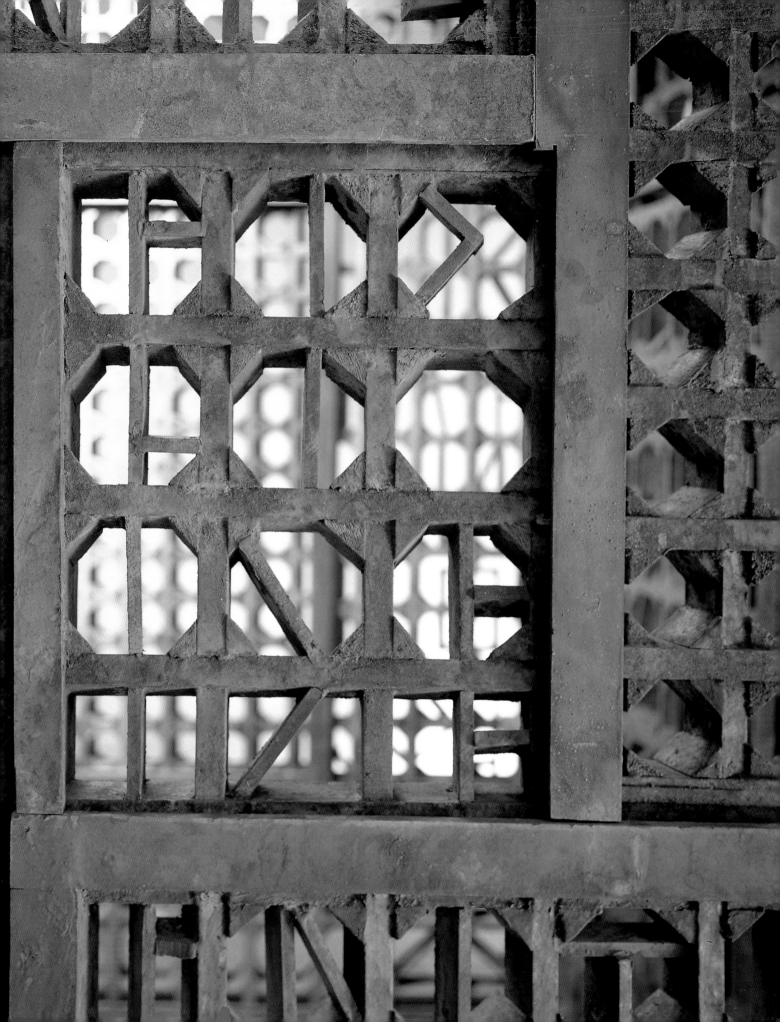

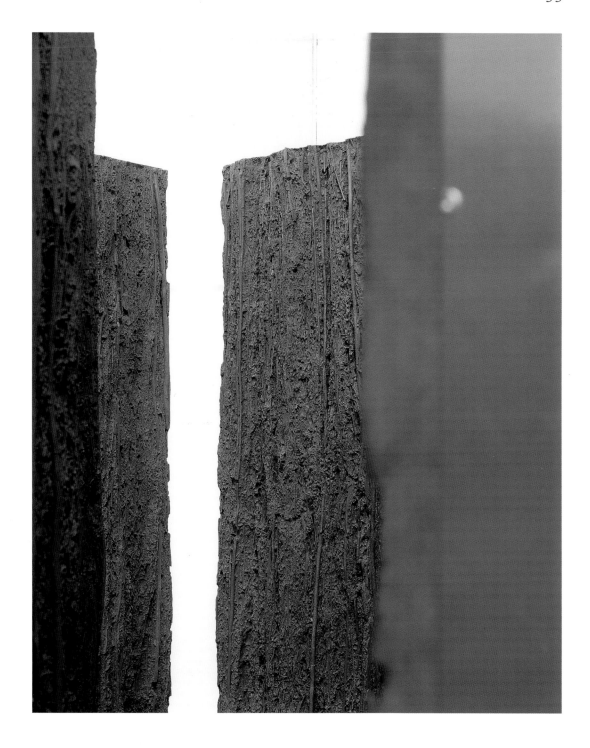

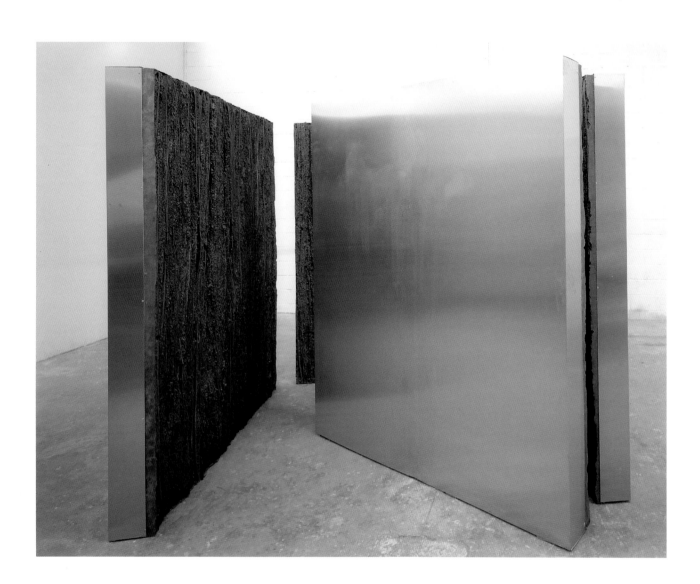

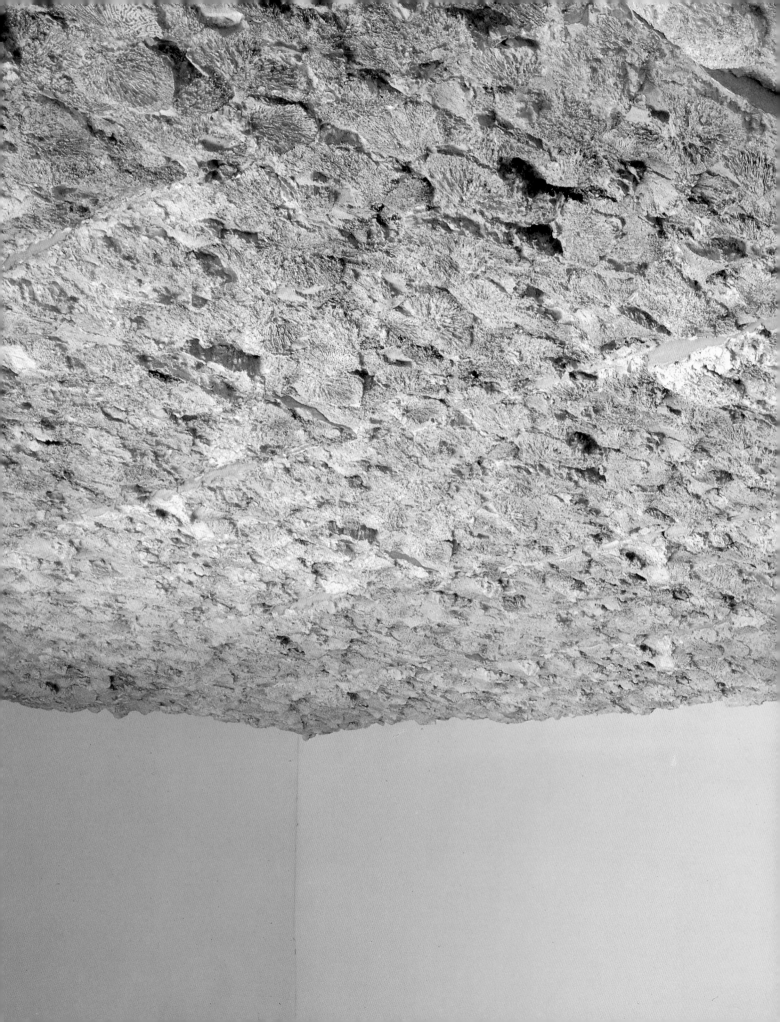

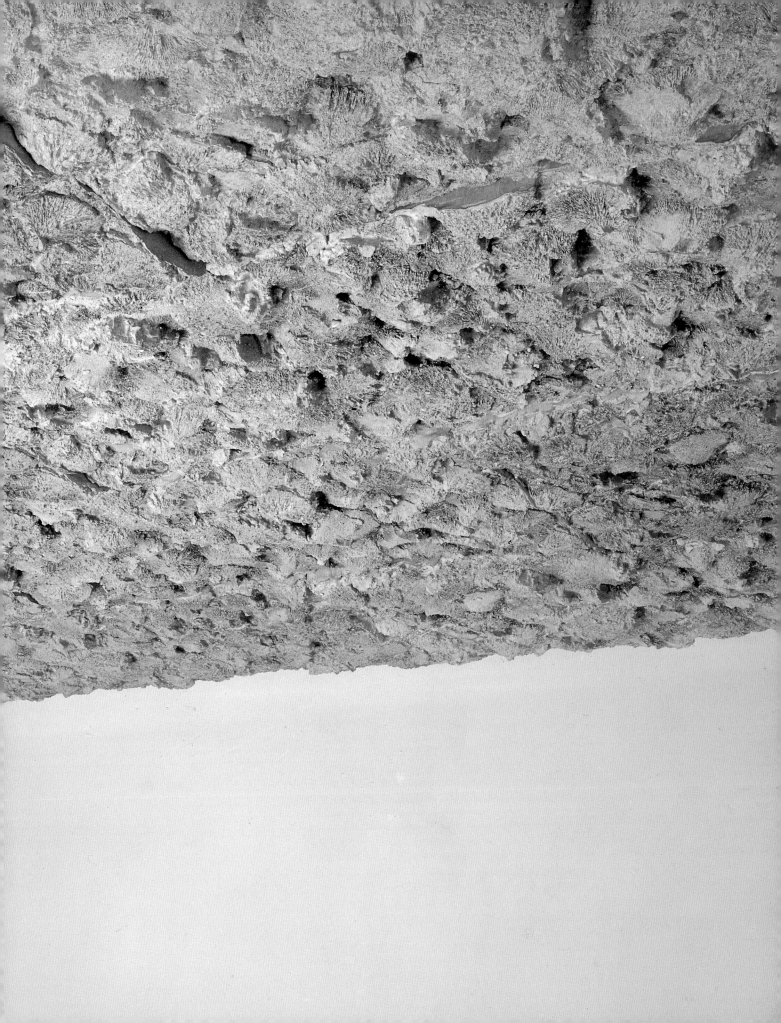

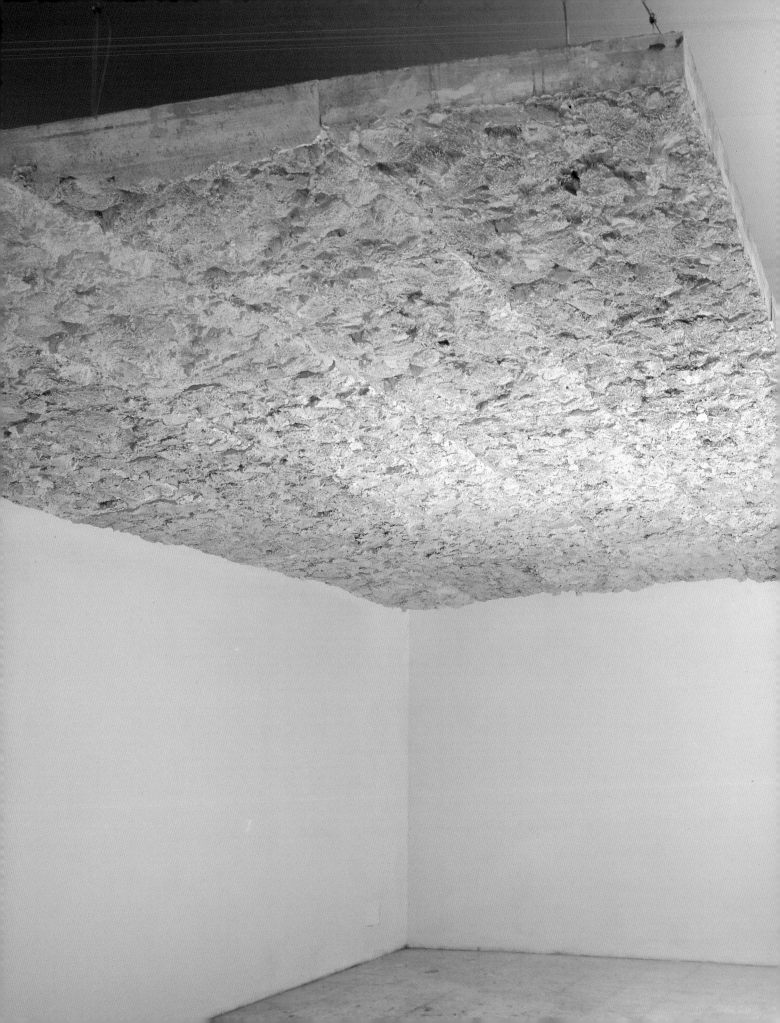

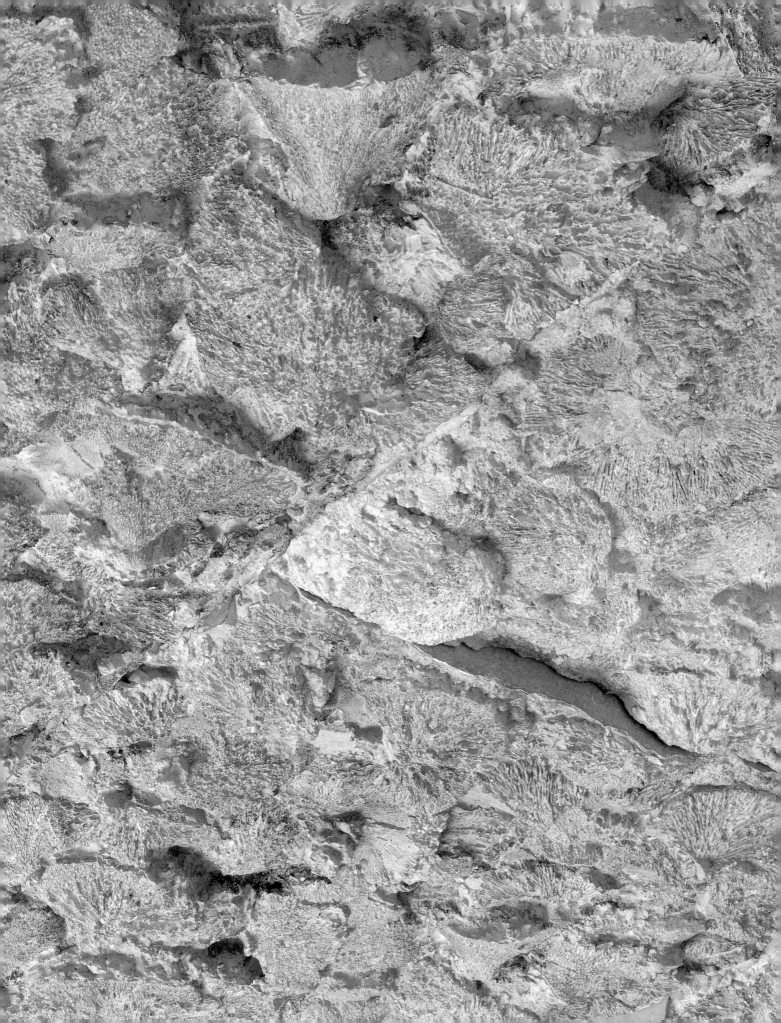

LIST OF ILLUSTRATIONS

————

EXHIBITION HISTORY & BIBLIOGRAPHY

Works of art included in the exhibition are denoted by an asterisk

COVER:

Detail of *Sin título (Celosía)*
(*Untitled [Jealousy]*), 1997⋆
Wood, resin, and bronze powder, 2.6 x 2.2 x 2.5 m
(8 feet 6 ⅜ inches x 7 feet 2 ⅝ inches x 8 feet 2 ⅜ inches)
BACOB Collection, Brussels

PAGE 12:

Photographic study, 1991

PAGE 15:

Installation view of *Cristina Iglesias*, Kunsthalle
Bern, 1991

LEFT:

Sin título (Untitled), 1988
Iron, wood, and glass, 2.1 x 1.3 x 1.3 m (6 feet
10 ⅝ inches x 4 feet 3 ⅛ inches x 4 feet 3 ⅛ inches)
Private collection, Belgium

RIGHT:

Sin título (Untitled), 1988
Iron, glass, and leather, 2 x 1.17 x 1.29 m (6 feet
6 ¾ inches x 3 feet 10 inches x 4 feet 2 ¾ inches)
Private collection, Belgium

PAGE 17:

Sin título (Untitled), 1990
Fibercement, aluminum, and red glass, 2.36 x 1.64 x
2.04 m (7 feet 8 ⅞ inches x 5 feet 4 ½ inches x
6 feet 8 ¼ inches)
Collection Bergé, Madrid

PAGE 18:

Sin título (Untitled), 1990
Fibercement, aluminum, and yellow glass, 2.02 x
2.4 x .6 m (6 feet 7 ½ inches x 7 feet 10 ½ inches x
1 foot 11 ⅝ inches)
Collection of the artist

PAGE 21:

Sin título (Untitled), 1990
Fibercement, iron, and blue glass, 2.3 x 1.4 x 1.2 m (7 feet
6 ½ inches x 4 feet 7 ⅛ inches x 3 feet 11 ¼ inches)
Carré d'Art, Musée d'Art Contemporain, Nîmes

PAGES 22, 24–25:

Installation views of *Espagne '87: Dynamiques et
Interrogations*, ARC, Musée d'Art Moderne de
la Ville de Paris, 1987

PAGE 28:

Sin título (Untitled), 1991
Fibercement and cast aluminum, 2.2 x 2.7 x 1 m (7 feet
2 ⅝ inches x 8 feet 10 ¼ inches x 3 feet 3 ⅜ inches)
Kunstmuseum Bern, Stiftung Kunsthalle Bern

PAGE 29:

Sin título (Untitled), 1993
Fibercement and resin, 2.5 x 2.2 x 1.5 m (8 feet
2 ⅜ inches x 7 feet 2 ⅝ inches x 4 feet 11 inches)
Collection of the artist

PAGE 31:

Sin título (Untitled), 1991
Fibercement, cast aluminum, and glass, 2.2 x 1.35 x
1 m (7 feet 2 ⅝ inches x 4 feet 5 ⅛ inches x 3 feet
3 ⅜ inches)
Courtesy of Jean Bernier Gallery, Athens

PAGE 33:

Sin título (Untitled), 1991
Fibercement, iron, and terra-cotta, 2.3 x 2.02 x 1.04 m
(7 feet 6 ½ inches x 6 feet 7 ½ inches x 3 feet 5 inches)
Courtesy of Jean Bernier Gallery, Athens

PAGES 34–35:

Installation views of *Espacio mental: René
Daniëls, Thierry de Cordier, Isa Genzken, Cristina
Iglesias, Thomas Schütte, Jan Vercruysse*, Instituto
Valenciano de Arte Moderno, Centre del Carme,
Valencia, 1991

PAGES 34 AND 35, LEFT:

Sin título (*Untitled*), 1988
Concrete, iron, and glass, 2.1 x 1.29 x 1.29 m (6 feet
10 ⅝ inches x 4 feet 2 ¾ inches x 4 feet 2 ¾ inches)
Private collection, Belgium

PAGE 35, RIGHT:

Sin título (*Untitled*), 1987
Concrete and iron, 2.1 x .7 x .65 m (6 feet 10 ⅝ inches x
2 feet 3 ½ inches x 2 feet 1 ⅝ inches)
BACOB Collection, Brussels

PAGES 36–37:

Sin título (*Untitled*), 1988
Concrete, iron, and glass, 2.1 x 1.29 x 1.29 m (6 feet
10 ⅝ inches x 4 feet 2 ¾ inches x 4 feet 2 ¾ inches)
DESTE Foundation for Contemporary Art, Athens

PAGES 38–41:

Installation views of *Cristina Iglesias: One Room*,
Stedelijk Van Abbemuseum, Eindhoven, 1994

PAGES 38–39, LEFT; 40, RIGHT; AND 41, LEFT TOP AND
BOTTOM (DETAILS):

Sin título (*Untitled*), 1994
Fibercement, iron, and alabaster, 2.4 x 2.07 x 1.95 m
(7 feet 10 ½ inches x 6 feet 9 ½ inches x 6 feet
4 ¾ inches)
Stedelijk Van Abbemuseum, Eindhoven

PAGES 38–39, RIGHT; 40, LEFT; AND 41, RIGHT TOP AND
BOTTOM (DETAILS):

Sin título (*Untitled*), 1994
Fibercement, iron, and alabaster, 2.4 x 2.29 x 2.26 m
(7 feet 10 ½ inches x 7 feet 6 ⅛ inches x 7 feet 5 inches)
Collection of the artist

PAGES 42–45:

Views of permanent installation, Katoennatie,
Antwerp (Paul Robbrecht and Hilde Daem,
architects)

Sin título (*Untitled*), 1992–93
Iron, alabaster, and colored glass; eight units,
approximately 3.7 x 3.1 x 3.4 m (12 feet 1 ⅝ inches x
10 feet 2 inches x 11 feet 1 ⅞ inches) each

PAGES 46, 49, 51–53:

Installation views of *Cristina Iglesias*, Spanish
Pavilion, *XLV Biennale di Venezia*, Venice, 1993

Sin título (Habitación de alabastro)
(*Untitled [Alabaster Room]*), 1993
Iron and alabaster; five units, dimensions variable
Collection of the artist

PAGES 56–57:

Installation views of *The Sublime Void (On the
Memory of the Imagination)*, Antwerp 93,
Koninklijk Museum voor Schone Kunsten,
Antwerp, 1993

Sin título (*Untitled*), 1993
Iron and alabaster, 4.32 x 2.7 x 3.92 m (14 feet
2 inches x 8 feet 10 ¼ inches x 12 feet 10 ⅜ inches)
Marugame Hirai Museum, Marugame, Japan

PAGES 58–59, 62–65, 67:

Installation views of *Cristina Iglesias*, Spanish
Pavilion, *XLV Biennale di Venezia*, Venice, 1993

PAGES 58; 59 (DETAIL); AND 62–63, RIGHT:

Sin título (Venecia II) (*Untitled [Venice II]*),
1993★
Fibercement, iron, and amber glass, 2.7 x 4.6 x 1.22 m
(8 feet 10 ¼ inches x 15 feet 1 ⅛ inches x 4 feet)
BACOB Collection, Brussels

PAGES 62–63, LEFT; 64–65; AND 67 (DETAIL):

Sin título (Venecia I) (*Untitled [Venice I]*), 1993★
Fibercement, tapestry, and glass, 2.5 x 3.6 x .6 m (8 feet
2 ⅜ inches x 11 feet 9 ¾ inches x 1 foot 11 ⅝ inches)
Collection of the artist

PAGE 69:

Sin título (*Untitled*), 1987
Concrete, iron, tapestry, and glass, 2.3 x 3 x 1.96 m
(7 feet 6 ½ inches x 9 feet 10 ⅛ inches x 6 feet
5 ⅛ inches)
Collection of the artist

PAGE 70:

Sin título (*Untitled*), 1991★
Fibercement, iron, tapestry, and amber glass, 2.03 x
2.2 x .5 m (6 feet 7 ⅞ inches x 7 feet 2 ⅝ inches x
1 foot 7 ⅝ inches)
Collection of the artist

PAGE 71:

Sin título (*Untitled*), 1988
Iron, glass, and leather, 2 x 1.17 x 1.2 m (6 feet
6 ¾ inches x 3 feet 10 inches x 3 feet 11 ¼ inches)
Private collection, Belgium

PAGES 73, 74 (DETAIL):

Sin título (*Untitled*), 1993–97★
Fibercement, iron, aluminum, and tapestry, 2.45 x
3.65 x .7 m (8 feet ½ inch x 11 feet 11 ¾ inches x
2 feet 3 ½ inches)
Collection of the artist

PAGE 75:

Sin título (*Untitled*), 1987
Iron, concrete, tapestry, and glass, 2.5 x 3 x .9 m (8 feet
2 ⅜ inches x 9 feet 10 ⅛ inches x 2 feet 11 ½ inches)
Collection of Wilfried and Yannick Cooreman,
Puurs, Belgium

PAGE 76, TOP:

Sin título (Lanzarote 5) (*Untitled [Lanzarote 5]*),
1996
Photo etching on paper, 1.08 x 1.2 m (3 feet 6 ½ inches x
3 feet 11 ¼ inches)
Collection of the artist

PAGE 76, BOTTOM:

Sin título (Lanzarote 6) (*Untitled [Lanzarote 6]*),
1996
Photo etching on paper, 1.08 x 1.2 m (3 feet 6 ½ inches x
3 feet 11 ¼ inches)
Collection of the artist

PAGE 77, TOP:

Sin título (Lanzarote 7) (*Untitled [Lanzarote 7]*),
1996
Photo etching on paper, 1.08 x 1.2 m (3 feet 6 ½ inches x
3 feet 11 ¼ inches)
Collection of the artist

PAGE 77, BOTTOM:

Sin título (Lanzarote 4) (*Untitled [Lanzarote 4]*),
1996
Photo etching on paper, 1.08 x 1.2 m (3 feet 6 ½ inches x
3 feet 11 ¼ inches)
Collection of the artist

PAGE 79:

Studies on the wall of the artist's studio,
Madrid, 1997

PAGE 81:

Sin título (Tríptico II) (*Untitled [Triptych II]*),
1994
Silkscreen on silk; triptych, 1.9 x 2.2 x .05 m (6 feet
2 ¾ inches x 7 feet 2 ⅝ inches x 2 inches) overall
Instituto Valenciano de Arte Moderno, IVAM Centre
Julio González, Generalitat Valenciana, Valencia

PAGE 82:

Sin título (Tríptico VII) (*Untitled [Triptych VII]*),
1997★
Silkscreen on silk; triptych, 1.8 x 2.5 x .05 m (5 feet
10 ⅞ inches x 8 feet 2 ⅜ inches x 2 inches) overall
Collection of the artist, Courtesy of Donald Young
Gallery, Seattle

PAGE 83:

Sin título (Tríptico VIII) (*Untitled [Triptych VIII]*),
1997★
Silkscreen on silk; triptych, 1.8 x 2.5 x .05 m (5 feet
10 ⅞ inches x 8 feet 2 ⅜ inches x 2 inches) overall
Collection of the artist, Courtesy of Donald Young
Gallery, Seattle

PAGE 84:

Sin título (Díptico IV) (*Untitled [Diptych IV]*),
1995*
Silkscreen on silk; diptych, 1.9 x 1.5 x .05 m (6 feet
2 ¾ inches x 4 feet 11 inches x 2 inches) overall
Courtesy of Donald Young Gallery, Seattle

PAGES 87, 92–93:

Installation views of *Cristina Iglesias*, Spanish
Pavilion, *XLV Biennale di Venezia*, Venice, 1993

Sin título (Hojas de laurel)
(*Untitled [Laurel Leaves]*), 1993
Fibercement and cast aluminum, 2.66 x 3.2 x .32 m
(9 feet 4 ¾ inches x 10 feet 6 inches x 1 foot ⅝ inch)
Universidad Nacional de Educación a Distancia, Madrid

PAGES 90–91:

Detail of *Sin título (Hojas de laurel)*
(*Untitled [Laurel Leaves]*), 1993

PAGES 94–95, 97:

Sin título (Hojas de laurel) (*Untitled [Laurel
Leaves]*), 1993, permanently installed in the
library of Universidad Nacional de Educación a
Distancia, Madrid

PAGES 98–99:

Views of permanent installation, Moskenes,
Lofoten Islands, Norway

Sin título (Islas Lofoten)
(*Untitled [Lofoten Islands]*), 1994
Fibercement, cast aluminum, and aluminum, 2.66 x
5.2 x 4.6 m (18 feet 8 ¾ inches x 17 feet ¾ inch x
15 feet 1 ⅛ inches)

PAGES 102–03 (DETAIL), 105:

Sin título (Hojas de eucaliptus II)
(*Untitled [Eucalyptus Leaves II]*), 1994*
Cast aluminum, 2.5 x 2.2 x .85 m (8 feet 2 ⅜ inches x
7 feet 2 ⅝ inches x 2 feet 11 ½ inches)
Courtesy of Galerie Konrad Fischer, Düsseldorf

PAGE 104:

Sin título (Hojas de eucaliptus I)
(*Untitled [Eucalyptus Leaves I]*), 1994
Cast aluminum, 2.5 x 2 x .92 m (8 feet 2 ⅜ inches x
6 feet 6 ¾ inches x 3 feet ¼ inch)
Museo de Bellas Artes de Alava, Vitoria, Spain

PAGES 109, 110–11, 112–13:

Installation views of *Cristina Iglesias*, Galerie
Konrad Fischer, Düsseldorf, 1994

PAGES 109, LEFT; 110–11, RIGHT; AND 112–13 (DETAIL):

Sin título (Cañas de bambú I)
(*Untitled [Bamboo Sticks I]*), 1994
Cast aluminum, 2.4 x 1 x .75 m (7 feet 10 ½ inches x
3 feet 3 ⅜ inches x 2 feet 5 ½ inches)
Stedelijk Van Abbemuseum, Eindhoven

PAGE 109, RIGHT:

Sin título (Tríptico II) (*Untitled [Triptych II]*),
1994
Silkscreen on silk; triptych, 1.9 x 2.2 x .05 m (6 feet
2 ¾ inches x 7 feet 2 ⅝ inches x 2 inches) overall
Instituto Valenciano de Arte Moderno, IVAM Centre
Julio González, Generalitat Valenciana, Valencia

PAGES 110–11, LEFT:

Sin título (Untitled), 1994
Cast aluminum and iron, 1.35 x 1.03 x .43 m (4 feet
5 ⅛ inches x 3 feet 4 ½ inches x 1 foot 4 ⅞ inches)
Private collection, Belgium

PAGES 115–19:

Installation views, *Cristina Iglesias*, Donald
Young Gallery, Seattle, 1996

PAGES 115, LEFT, AND 116–17, LEFT:

Sin título (Bosque de bambú I)
(*Untitled [Bamboo Forest I]*), 1995
Cast aluminum, 2.4 x 2.3 x 1.88 m (7 feet 10 ½ inches x
7 feet 6 ½ inches x 6 feet 2 inches)
Paul and Camille Oliver Hoffmann, Chicago,
Courtesy of Donald Young Gallery, Seattle

PAGES 115, RIGHT; 116–17, RIGHT; AND 118–19, LEFT:

Sin título (Bosque de bambú II)
(*Untitled [Bamboo Forest II]*), 1995★
Cast aluminum, 2.4 x 2.5 x .6 m (7 feet 10 ½ inches x
8 feet 2 ⅜ inches x 1 foot 11 ⅝ inches)
Courtesy of Donald Young Gallery, Seattle

PAGES 118–19, RIGHT:

Sin título (Bosque de bambú III)
(*Untitled [Bamboo Forest III]*), 1995
Cast aluminum, 2.4 x 2.2 x .85 m (7 feet 10 ½ inches x
7 feet 2 ⅝ inches x 2 feet 9 ½ inches)
Courtesy of Donald Young Gallery, Seattle

PAGE 120:

Sin título (Tríptico IV) (Untitled [Triptych IV]),
1997★
Silkscreen on silk; triptych, 2 x 2.5 x .05 m (6 feet
6 ¾ inches x 8 feet 2 ⅜ inches x 2 inches) overall
Collection of the artist, Courtesy of Donald Young
Gallery, Seattle

PAGE 121:

Sin título (Tríptico V) (Untitled [Triptych V]),
1997★
Silkscreen on silk; triptych, 2 x 2.5 x .05 m (6 feet
6 ¾ inches x 8 feet 2 ⅜ inches x 2 inches) overall
Collection of the artist, Courtesy of Donald Young
Gallery, Seattle

PAGE 123:

Installation view, *Cristina Iglesias*, Donald Young
Gallery, Seattle, 1996

LEFT:

Sin título (Tríptico III) (Untitled [Triptych III]),
1995★
Silkscreen on silk; triptych, 1.9 x 2.2 x .05 cm (6 feet
2 ¾ inches x 7 feet 2 ⅝ inches x 2 inches) overall
Courtesy of Donald Young Gallery, Seattle

RIGHT:

Sin título (Díptico IV) (Untitled [Diptych IV]),
1995★
Silkscreen on silk; diptych, 1.9 x 1.45 x .05 m (6 feet
2 ¾ inches x 4 feet 9 inches x 2 inches) overall
Courtesy of Donald Young Gallery, Seattle

PAGES 124–25 (DETAIL), 127:

Sin título (Bosque de bambú oxidado)
(*Untitled [Iron Bamboo Forest]*), 1996
Iron and resin, 2.5 x 4.7 x 3.2 m (8 feet 2 ⅜ inches x
15 feet 5 inches x 10 feet 6 inches)
Banco Guipuzcoano, San Sebastián

PAGES 128 (DETAIL), 129, 130–31 (DETAIL):

Sin título (Celosía) (Untitled [Jealousy]), 1997★
Wood, resin, and bronze powder, 2.6 x 2.2 x 2.5 m (8 feet
6 ⅜ inches x 7 feet 2 ⅝ inches x 8 feet 2 ⅜ inches)
BACOB Collection, Brussels

PAGES 132–33 (DETAILS), 135:

Sin título (Habitación de acero inoxidable)
(*Untitled [Stainless Steel Room]*), 1997★
Iron, resin, and stainless steel, 2.5 x 3.15 x 3.15 m (8 feet
2 ⅜ inches x 10 feet 4 inches x 10 feet 4 inches)
Collection of the artist

PAGES 136–37 (DETAIL), 138–39, 140 (DETAIL):

Sin título (Techo suspendido inclinado)
(*Untitled [Hanging Tilted Ceiling]*), 1997★
Iron, resin, and stone powder, .1 x 9.15 x 6 m
(3 ⅞ inches x 30 feet ¼ inch x 19 feet 8 ¼ inches)
Collection of the artist, Courtesy of Donald Young
Gallery, Seattle

Born November 1956 in San Sebastián. Lives and works in Madrid.

SOLO EXHIBITIONS

1984

Casa de Bocage, Galeria Municipal de Arte Visuais de Setúbal, Portugal. *Cristina Iglesias—Arqueologías.* June 8–July 5. Exh. cat., with text by Antonio Cerveira-Pinto. In Portuguese and English; trans. Isabel Correia.

Galeria Cómicos, Lisbon. *Sequências.* September 11–October 6.

Galería Juana de Aizpuru, Madrid. *Cristina Iglesias.* October 14–November 9.

1986

Galeria Cómicos, Lisbon. *Cristina Iglesias.* December 2–31.

1987

C.A.P.C. Museé d'Art Contemporain, Bordeaux. *Cristina Iglesias: Sculptures de 1984 à 1987.* September 25–November 22. Exh. cat., with text by Alexandre Mélo. In English, Spanish, and French; trans. Irène Bloc, Pascale de Los Angeles, and Jean-Marie Vriaud.

Galería Marga Paz, Madrid. *Cristina Iglesias.* October 30–November 30.

Galerie Peter Pakesch, Vienna. *Cristina Iglesias.* April 5–May 2.

1988

Jean Bernier Gallery, Athens. *Cristina Iglesias.* April 28–May 19.

Museo de Bellas Artes, Málaga. *Cristina Iglesias.* May.

Kunstverein für die Rheinlande und Westfalen, Düsseldorf. *Cristina Iglesias.* June 29–July 31. Exh. cat., with texts by Aurora García and Jiri Svesta and reprinted statement by Iglesias (from exh. cat., *Cristina Iglesias* [Lisbon: Galeria Cómicos, 1986]). In German and English;

trans. Stefan Barmann, Michael Biberstein, Ana Gusmao, Klaus Kapp, Irmgard Schnell, José Lebrero Stals, and Cristina Ward.

Galerie Joost Declercq, Ghent. *Cristina Iglesias.* November 5–December 17.

1989

Galerie Ghislaine Hussenot, Paris. *Cristina Iglesias.* November 30, 1989–January 10, 1990.

1990

Galleria Locus Solus, Genoa. *Cristina Iglesias/Lili Dujourie.* Exh. cat., with introduction by Bart Cassiman.

Galería Marga Paz, Madrid. *Cristina Iglesias.* February/March.

De Appel Foundation, Amsterdam. *Cristina Iglesias.* February 7–March 11. Exh. cat., with text by Bart Cassiman. In English and Dutch; trans. John Rudge.

Galeria Cómicos, Lisbon. *Cristina Iglesias, Esculturas recentes.* November 27, 1990–January 4, 1991. Exh. cat., with text by Iglesias. In Spanish and English; trans. Michael Biberstein.

1991

Kunsthalle Bern. *Cristina Iglesias.* March 16–April 28. Exh. cat., with texts by Ulrich Loock and José Angel Valente. In Spanish, German, and English; trans. Margret Joss and Petra Strien.

Jean Bernier Gallery, Athens. *Cristina Iglesias.* April 12–May 10.

Galerie Joost Declercq, Ghent. *Cristina Iglesias.* December 18, 1991–January 25, 1992.

1992

Art Gallery of York University, North York, Ontario. *Cristina Iglesias.* September 23–November 1. Exh. cat., with text by Pepe Espalíu and preface by Loretta Yarlow. In English and Spanish.

1993

Galeria Municipal de Arte ARCO, Faro, Portugal.
Cristina Iglesias, Esculturas. May 8–June 18.

Pabellón de España, XLV Biennale di Venezia,
Venice. *Cristina Iglesias.* June 13–October 10.
Exh. cat., with texts by Aurora García and José
Angel Valente. In English and Spanish; trans.
Joanna Martinez and Cristina Ward.

Mala Galerija, Moderna Galerija, Ljubljana,
Slovenia. *Cristina Iglesias.* October 12–
December 5. Exh. cat., with text by Zdenka
Badovinac. In Slovene and English; trans.
Mika Briski and Tamara Soban.

Galerie Ghislaine Hussenot, Paris. *Cristina Iglesias.*
December 11, 1993–January 15, 1994.

1994

Stedelijk Van Abbemuseum, Eindhoven. *Cristina
Iglesias: One Room.* June 25–September 4.

Galerie Konrad Fischer, Düsseldorf. *Cristina
Iglesias.* October 22–November 19.

1996

Jean Bernier Gallery, Athens. *Cristina Iglesias.*
January 16–February 24.

Donald Young Gallery, Seattle. *Cristina Iglesias.*
March 7–April 26.

Galería DV, San Sebastián. *Cristina Iglesias.*
July/August. Exh. cat., with text by Francisco
Jarauta. In Spanish and English; trans.
KADE Traducciones.

GROUP EXHIBITIONS

1983

Caja de Ahorros y Monte de Piedad, Casa del
Monte, Palacio de las Alhajas, Madrid. *La
Imagen del Animal: Arte Prehistórico, Arte
Contemporáneo.* December 1983–January 1984.
Exh. cat., with texts by Julio Caro Baroja,
Ramón Bilbao, Joseph Beuys, Manuel Martín
Bueno, Mario Merz, Juan Muñoz, and Eduardo
Ripoll Perelló. Traveled to Caixa de Barcelona,
Barcelona, March-April (exh. cat., in Catalan;
trans. Agustí Béjar, Mar Erice, David Reher,
and Caridad Torres).

1985

Stedelijk Van Abbemuseum, Eindhoven. *Christa
Dichgans, Lili Dujourie, Marlene Dumas, Lesley
Foxcroft, Kees de Goede, Frank van Hemert,
Cristina Iglesias, Harald Klingelhöller, Mark
Luyten, Juan Muñoz, Katherine Porter, Julião
Sarmento, Barbara Schmidt Heins, Gabriele
Schmidt-Heins, Didier Vermeiren.* May 24–
June 30. Exh. cat., with text on Iglesias by
Lourdes Iglesias. In English; trans. G. E. Luton.

Galería Fúcares, Almagro, Spain. *Punto y final.*
June/July.

Galería Juana de Aizpuru, Madrid. *El desnudo.*
July 10–September 16.

1986

Pabellón Mudéjar, Seville. *17 Artistas/
17 Autonomías.* February 28-April 6. Exh. cat.,
with text by Marga Paz. Traveled to La Lonja,
Palma de Mallorca, summer.

Diputación Provincial de Málaga, Antiguo
Colegio de San Agustín, Málaga.
8 de Marzo. March 8–21. Exh. cat., with
text by Mar Villaespesa.

Fundación Caja de Pensiones, Madrid. *1981–1986
Pintores y Escultores Españoles.* April 9–May 11.
Exh. cat., with text by Kevin Power. In Spanish
and English; trans. Margarita Borja.

Pabellón de España, XLII Biennale di Venezia, Venice. *Ferrán García Sevilla, Cristina Iglesias, Miguel Navarro, José María Sicilia*. June 29–September 28. Exh. cat., with texts by Marga Paz, Francisco Calvo Serraller, and Ana Vázquez de Parga. In Spanish and English.

Museo Español de Arte Contemporáneo, Madrid. *VI Salón de los 16*. Opened July 9. Exh. cat., with text by Miguel Logroño.

Galeria Cómicos, Lisbon. *L'attitude*. September 4–October 11.

VIII Bienal de Escultura, Zamora. *Escultura Ibérica Contemporánea*. September 20–October 20. Exh. cat., with texts by Javier González de Durana and Kosme María de Barañano.

Galería Juana de Aizpuru, Madrid. *Escultura sobre la pared*. October 24–December 11.

1987

De Appel Foundation, Amsterdam. *Muur voor een schilderij/Vloer voor een sculptuur*. May 9–24.

Fort Asperen Acquoy, Acquoy, Netherlands. *Beelden en Banieren*. Summer. Exh. cat., with texts by R. H. Fuchs and Piet de Jonge. In Dutch and English; trans. Beth O'Brien.

Galería Juana de Aizpuru, Madrid. *Proyecto para una colección de arte actual*. July 15–September 20.

Fonds Régional d'Art Contemporain des Pays de la Loire, Abbaye Royale de Fontevraud, France. *Quatrièmes Ateliers Internationaux des Pays de la Loire*. September 12–November 1. Exh. cat., with text on Iglesias by Chris Dercon. In French and English. Traveled to Pole d'Animation et de Rencontres Culturelles (PARC), Manufacture des Tabacs, Nantes, November 20, 1987–January 17, 1988; Museé d'Art et Archéologie de la Roche-sur-Yon, France; February 13–March 21, 1988; Palais des Congrés de la Ville du Mans, France, April 5–May 8, 1988; Palais des Congrés de la Ville de Saint-Jean-de-Monts, France, May 21–June 28, 1988; and Office Social et Culturel de Château-Gontier, Chapelle Saint-Julien de l'Hôpital de Château-Gontier, France, July 2–August 21, 1988.

ARC, Musée d'Art Moderne de la Ville de Paris. *Cinq Siècles d'art espagnol. Espagne '87: Dynamiques et Interrogations*. October 10–November 22. Exh. cat., with text on Iglesias by Carmen Gallano. In French; trans. Sylvie Bignon, Alexandre de Castellane, and Sara Mirkovitch.

1988

Galería Juana de Aizpuru, Madrid. *Escultura*. July 4–September 30.

Royal Dublin Society, The Guinness Hop Store and the Royal Hospital Kilmainham, Dublin. *ROSC '88*. August 19–October 15. Exh. cat., with texts by Aidan Dunne, Olle Granath, Rosemarie Mulcahy, and Angelica Zander Rudenstine.

Donald Young Gallery, Chicago. *Three Spanish Artists: Cristina Iglesias, Pello Irazu, Fernando Sinaga*. September 13–October 22. Exh. brochure, with text by Aurora García.

Rotonda di Via Besana and Studio Marconi, Milan. *Artisti Spagnoli Contemporanei*. October 11–November 20. Exh. cat., with texts by Dan Cameron, Mariano Navarro, and Kevin Power.

Galerie Barbara Farber, Amsterdam. *Spanish Sculpture*. October 29–November 30.

1989

Centre Albert Borschette, Brussels. *Jeunes Sculpteurs espagnols: Au ras du sol, le dos au mur*. January 23–May 30. Exh. cat., with text by Fernando Huici. In Spanish and French; trans. Dragoman SA and J. P. Potin.

Museum of Modern Art, Takanawa, Japan. *Spain Art Today*. April 29–June 12. Exh. cat., with text by Miguel Fernández-Cid. In Japanese and Spanish.

Galerie Joost Declercq, Ghent; Galerie Max Hetzler, Cologne; Luhring Augustine Gallery, New York; Galerie Peter Pakesch, Vienna; Galería Marga Paz, Madrid; and Galleria Mario Pieroni, Rome. *Forg, Iglesias, Spaletti, Vercruysse, West, Wool.* Summer. Exh. brochure.

House of Cyprus, DESTE Foundation for Contemporary Art, Athens. *Psychological Abstraction.* July 18–September 16. Exh. cat., with text by Jeffrey Deitch. In Greek and English; trans. Athena Schina.

Casa de Parra, Santiago de Compostela. *Presencia e procesos sobre as ultimas tendencias da arte.* October. Exh. brochure.

1990

The Eighth Biennale of Sydney, Art Gallery of New South Wales. *The Readymade Boomerang: Certain Relations in Twentieth Century Art.* April 11–June 3. Exh. cat., with statement by Iglesias. In English; trans. Michael Biberstein.

Centro Atlántico de Arte Moderno, Las Palmas. *Hacia el Paisaje/Towards Landscape.* October 16–November 30. Exh. cat., with texts by Aurora García and Denys Zacharopoulos. In Spanish and English; trans. Adolfo García Ortega, Charles Penwarden, and Africa Vidal.

1991

Martin-Gropius-Bau, Berlin. *Metropolis.* April 20–July 21. Exh. cat., with texts by Jeffrey Deitch, Wolfgang Max Faust, Vilém Flusser, Boris Groys, Jenny Holzer, Christos M. Joachimides, Dietmar Kamper, Achille Bonito Oliva, Norman Rosenthal, Christoph Tannert, and Paul Virilio. In English; trans. David Britt, Christian Caryl, Vittoria Di Palma, Chris Kraus, Michael Robinson, and Yvonne Shafir.

Instituto Valenciano de Arte Moderno, Centre del Carme, Valencia. *Espacio mental: René Daniëls, Thierry de Cordier, Isa Genzken, Cristina Iglesias, Thomas Schütte, Jan Vercruysse.* May 10–July 21. Exh. cat., with text by Bart Cassiman.

In Spanish, English, and Dutch; trans. Anita Buysse and Harry Smith.

Louver Gallery, New York. *Clemente, Doren, Iglesias, Mol, Sarmento.* June 1–July 3.

Galería Marga Paz, Madrid. *Rodney Graham, Cristina Iglesias, Tony Cragg.*

1992

Donald Young Gallery, Seattle. *Group Show.* January 17–April 8.

Instituto Valenciano de Arte Moderno, Valencia. *Colección del IVAM. Adquisiciones 1985-1992.* February 7–April 5. Exh. cat., with texts by Carmen Alborch, Tomàs Llorens, Vicente Todolí, and J. F. Yvars.

Estación Plaza de Armas, Seville. *Los 80 en la colección de la Fundación "La Caixa."* April 11–June 20. Exh. cat., with texts by Mariano Navarro, Kevin Power, and Evelyn Weiss. In Spanish and English; trans. Berit Balzer, Dru Dougherty, Ana Eiroa Guillén, Brian Hughes, Miguel Angel Pérez, Isidro Pliego, Francisco Javier Torres Ribelles, Helena Rouse, and María Teresa Cruz Yabar.

Salas del Arenal, Seville. *Los Ultimos Días/The Last Days.* April 19–May 13. Exh. cat., with texts by Juan Vicente Allaga, José Luis Brea, Massimo Cacciari, Dan Cameron, Manel Clot, Francisco Jarauta. In Spanish and English; trans. Fabián Chueca Crespo, Alberto Gómez Font, Maruja García Padilla, Tom Skipp, and John Suau.

Pabellón de España, Exposición Universal de Sevilla 1992, Seville. *Pasajes: Actualidad del Arte español.* April 20–October 12. Exh. cat., with texts by Teresa Bianchi and José Luis Brea.

Centro Cultural Tecla Sala, Hospitalet, Barcelona. *Tropismes.* July 11–August 15. Exh. cat., with texts by Nimfa Bisbe, Dan Cameron, and Rosa Queralt. In Spanish, Catalan, and English; trans. Montse Cunill, Ignasi Sarda, and Graham A. Thompson.

Donald Young Gallery, Seattle. *Group Show.* July 24–September 12.

Edinburgh. *Lux Europae*. October 22–January 5. Exh. cat., with texts by Sacha Craddock and Duncan MacMillan and interview with Kaspar König. In English.

1993

Charlottenborg, Copenhagen. *Juxtaposition*. April 29–June 6. Exh. cat., with texts by Mikkel Borgh and John Peter Nielsson. In Danish and English; trans. Martha Gaber Abrahamsen.

Donald Young Gallery, Seattle. *Group Show*. May 1993–January 15, 1994.

Antwerp 93, Koninklijk Museum voor Schone Kunsten, Antwerp. *The Sublime Void (On the Memory Of the Imagination)*. July 25–October 10. Exh. cat., with introduction by Bart Cassiman.

Palacio de Velázquez, Madrid. *XIII Salón de los 16*. September 21–October 30. Exh. cat., with text by Miguel Fernández-Cid. Traveled to Auditorio de Galicia, Santiago de Compostela.

1994

Koldo Mitxelena Kulturunea, San Sebastián. *Bildumak/Colecciónes*. March 29–May 29. Exh. cat., with texts by Xavier Sáenz de Gorbea, Gloria Picazo, and Frederic Oyharcabal. In Basque, Spanish, French; trans. BITEZ.

Kunsthalle Bern. *Spuren von Ausstellungen der Kunsthalle in zeitgenossischer Kunst*. May 7–June 19. Exh. cat., with text by Ulrich Loock.

Donald Young Gallery, Seattle. *Group Show*. June 1–November 12.

Moskenes, Lofoten Islands, Norway. *Artscape Norway*. Opened June. Permanent installation of *Untitled (Lofoten Islands)*.

Instituto Cervantes, Rome. *La voce del Genere*. October 26–November 26. Exh. cat., with text on Iglesias by Mar Villaespesa. In Italian and Spanish; trans. Luciano Scatolini.

1995

Cruce, Madrid. *12 Esperientze/experiencias: Taller de serigrafía, Arteleku 1994*. February 27–March 16. Exh. cat., with texts by Pepe Albacete and Iglesias. In Basque, Spanish, and English; trans. BITEZ. Traveled to Arteleku, San Sebastián, May.

Chisenhale Gallery, London. *Lili Dujourie/Pepe Espaliu/Cristina Iglesias*. September 23–October 29, 1995. Exh. cat., *Some Notes on Nothing, and the Silence of Works of Art*, with text by Michael Newman.

Henry Moore Institute, Leeds. *Gravity's Angel*. September 28–December 30. Exh. cat., with text by Penelope Curtis.

Museum of Art, Carnegie Institute, Pittsburgh. *1995 Carnegie International*. November 4, 1995–February 18, 1996. Exh. cat., with introduction by Richard Armstrong.

Jean Bernier Gallery, Athens. *Andreas Gursky, Cristina Iglesias, Juan Muñoz, Eric Poitevin, Yvan Salomone, Pia Stadtbaumer, Sue Williams*. November 30, 1995–January 10, 1996.

1997

Kunsthalle Bern. *Ten Years of the Foundation of the Kunsthalle Bern*. January 29–March 2. Exh. cat., with text by Ulrich Loock. In German.

Palacio de Velázquez, Madrid. *En la Piel de Toro*. May 14–September 8. Exh. cat., with texts by Aurora García and Joaquín Magalhaes. In Spanish and English; trans. José Angel Cilleruelo and Nigel Williams.

SELECTED BIBLIOGRAPHY

Please refer to the Exhibition History for information about exhibition catalogues and related publications.

Interviews
Reindl, Uta M. "Kunstlerporträts: Cristina Iglesias." *Kunstforum International* (Cologne), no. 94 (April–May 1988), pp. 132–35.

Vasconcelos, Helena. "Entrevista con Cristina Iglesias." *Figura* (Seville), nos. 7–8 (spring 1986), pp. 51–53.

Monograph
Maderuelo, Javier. *Cristina Iglesias: Cinco Proyectos.* Artistas Españoles Contemporáneos (Madrid: Fundación Argentaria, 1996).

Selected Articles and Reviews
Artner, Alan G. "At the Galleries: Exploring the Flower of Mortality: Cristina Iglesias, Pello Irazu, Fernando Sinaga." *Chicago Tribune*, October 20, 1988, section 5, p. 12.

Calvo Serraller, Francisco. "Una revelación convincente." *El País* (Madrid), October 22, 1984.

———. "La Nouvelle Sculpture espagnole." *Art Press* (Paris), no. 117 (September 1987), pp. 17–20.

Cembalest, Robin. "Learning to Absorb the Shock of the New." *ARTnews* (New York) 88, no. 7 (September 1989), pp. 127–31.

Fernández-Cid, Miguel. "A tiempo para la escultura?" *Lápiz* (Madrid), no. 36 (October 1986).

Fredericksen, Eric. "Cristina Iglesias at Donald Young: Feminine Mystique." *The Stranger Weekly* (Seattle) 5, no. 27 (March 27–April 2, 1996), p. 20.

Gambrell, Jamey. "Five from Spain." *Art in America* (New York) 9, no. 75 (September 1987), pp. 160–71.

García, Aurora. "Galería Marga Paz, Madrid." *Artforum* (New York), no. 26 (February 1988), pp. 155–56.

Grant, Simon. "Lili Dujourie/Pepe Espalíu/Cristina Iglesias; Chisendale Gallery, London. Gravity's Angel; Henry Moore Institute, Leeds." *Art Monthly* (London), no. 191 (November 1995), pp. 35–37.

Grout, Catherine. "Cristina Iglesias, Juan Muñoz: Sculptures." *Artstudio* (Paris), no. 14 (autumn 1989), pp. 110–17. In French.

Hackett, Regina. "Iglesias' Mind-Bending Murals and Sculptures Take Hold in U.S." *Seattle Post Intelligencer* (Seattle), March 15, 1996, p. 18.

Hansel, Sylvaine. "Berufung auf die eigene Tradition." *Weltkunst* (Munich) 60, no. 9 (May 1990), pp. 1392–396.

Kangas, Matthew. "Seattle: Cristina Iglesias, Donald Young Gallery." *Sculpture* (Washington, D.C.), no. 15 (July–August 1996), pp. 60–61.

Koether, Jutta and Diedrich Diederichsen. "Jutta and Diedrich Go to Spain: Spanish Art and Culture Viewed from Madrid." *Artscribe International* (London), no. 59 (September–October 1986), pp. 56–61.

Mélo, Alexandre. "Cristina Iglesias, obras en cemento." *Journal des Lettres*, September 1984.

———. "Cristina Iglesias, a Free Exercise of Intelligence." *Flash Art* (Milan), no. 138 (January–February 1988), pp. 91–92.

———. "Galeria Cómicos, Lisbon." *Artforum* (New York), no. 29 (May 1991), p. 157.

Murria, Alicia. "Venezia: la Biennale." *Lápiz* (Madrid) 11, no. 93 (May 1993), pp. 20–23.

"Neue Ankaufe der Stiftung Kunsthalle Bern." *Berner Kunstmitteilungen* (Bern), no. 281 (September–October 1991), pp. 11–13.

Olivares, Rosa, Jiménez, Carlos, Murria, Alicia, and Montolio, Celia. "Bienal de Venecia." *Lápiz* (Madrid) 11, no. 94 (1993), pp. 42–55.

Pérez Villén, Angel L. "La Vanitas neobarroca." *Lápiz* (Madrid) 10, no. 87 (May–June 1992), pp. 64–67.

Proctor, Nancy. "Playing to the Gallery." *Women's Art Magazine* (London), no. 68 (January–February 1996), pp. 19–21.

Solomon, Barbara Probst. "Out of the Shadows: Art in Post-Franco Spain." *ARTnews* (New York) 86, no. 8 (October 1987), pp. 120–24.

Stoltz, George. "Madrid: Cristina Iglesias," part of "Fast Forward (Nineteen Artists Whose Works Are Gaining Recognition)." *Artnews* (New York) 92, no. 9 (November 1993), pp. 130–31.

Tarantino, Michael. "Joost Declercq, Ghent." *Artforum* (New York), no. 27 (February 1989), p. 146.